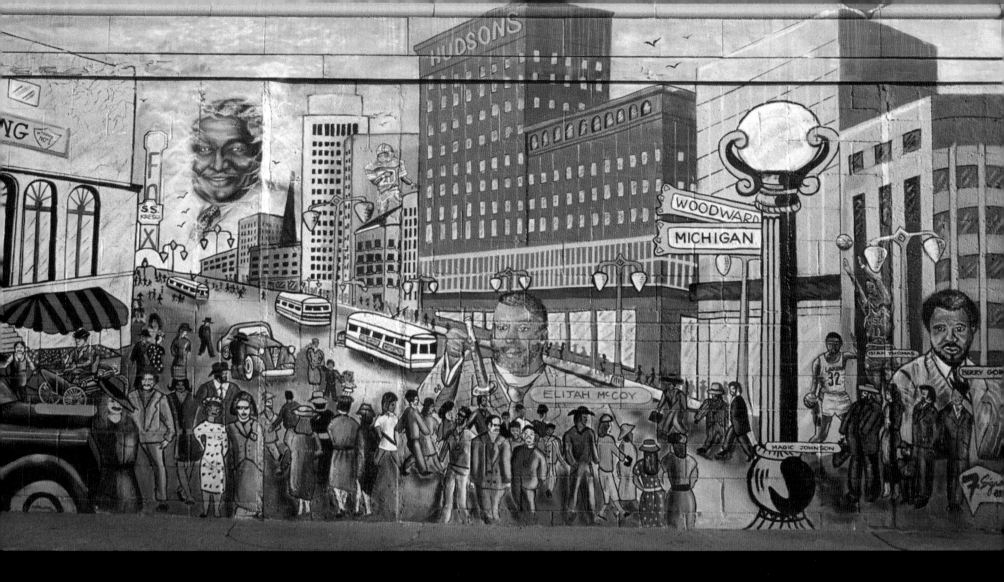

TALKING SHOPS
Detroit Commercial Folk Art

DAVID CLEMENTS

Foreword by Bill Harris ☆ Afterword by Jerry Herron

TALKING SHOPS

TALKING SHOPS

Detroit Commercial Folk Art

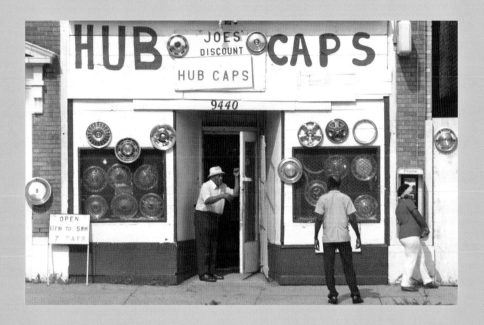

DAVID CLEMENTS

Foreword by Bill Harris • Afterword by Jerry Herron

WAYNE STATE UNIVERSITY PRESS

DETROIT

Cax
Library of Congress Cataloging-in-Publication Data

Clements, David, 1948–
 Talking shops : Detroit commercial folk art / David Clements ; foreword by Bill Harris ; afterword by Jerry Herron.
 p. cm. — (Great Lakes books)
 ISBN 0-8143-3090-8 (pbk. : alk. paper)
 1. Painted signs and signboards—Michigan—Detroit—Pictorial works. 2. Commercial art—Michigan—Detroit—Pictorial works. 3. Folk art—Michigan—Detroit—Pictorial works. 4. Detroit (Mich.)—Social life and customs—Pictorial works. I. Title. II. Series.
 GT3911.M5D63 2005
 741.6'7'0977434—dc22
 2004009796

Published with the support of the City of Detroit Cultural Affairs Department and the Michigan Council for the Arts and Cultural Affairs as well as the Richard Kinney Publication Fund and the Art Book Fund of Wayne State University Press.

Preface

Cruising through the streets of Detroit—its neighborhoods and industrial landscapes—I feel a vibrant and evolving city. I have discovered on these city streets the fruits of fun- and life-filled efforts to maintain safety and prosperity. Brightly colored storefronts, auto-repair shops, and hair salons shout their messages to passersby with portraits of business owners, classic hairstyles, and dreams of driving sharp cars. Art meets commerce.

The photographs in this book reflect a historic, Detroit-style American folk art. Even more so than diners and roadside attractions, the images of America's changing commercial landscape are fleeting and should be documented, if not pre-served. The images are uniquely American, and for that reason alone their existence deserves some cultural awareness. Looking through this book, I hope you will discover the cumulative energy of these photographs that document our own history in our own time. Through them, I hope you will learn to enjoy looking around a little more to discover unique slices of life and vitality in your own environment.

David Clements

Foreword

Bill Harris

The function of a public sign is to convey information, whether spiritual, public, or commercial. The most effective signs are the most succinct and the least subtle. The images on them must be immediately captivating, and the goods or messages being offered must be recognizable as culturally condoned and personally necessary. This is true whether the product offered is designed to adorn one's body, better one's person, or maximize one's leisure.

By capturing the images of a particular area's exterior signage, self-described urban archaeologist David Clements allows for the concentrated study of a changing landscape. His photographs document the economic expansions and contractions, fads and fundamentals, of urban existence, specifically in Detroit, Michigan, in the twentieth and twenty-first centuries.

Talking Shops shows rather than tells. Although there is a mélange of subject matter and intentions, of methods and approaches, at the core of the project are signs, each in its own words and its own way relating a self-contained narrative on the American dream, the central theme of this collection.

Clements's photographs catalog people's hope of fulfilling the basic tenet of the Declaration of Independence: the pursuit of happiness. Whether the sign was executed by a school-trained hand, slap-dashed by an "outsider" amateur, or painted by the fledgling owner, the reason for its existence is the same. The hope of all ethnic and immigrant groups in America is to share equally in its promised possibilities. Individuals in all groups attempt, in their pursuit of happiness, to control the fruits of their labor. They seek to be independent of, and free from, the burden of second-class treatment and to be equitably compensated for their physical, mental, and economic contributions. The truest promise of that dream is to be self-employed—to be the owner, the boss, the CEO, no less so than Bill Gates or Sam Walton. In this regard each sign, whether unselfconsciously sincere, deliberately ironic, calculated, or naive, is as articulate as the Declaration of Independence. It is about the desire to have a piece of the dream.

Because all entrepreneurs are dependent on the kindness and desires of strangers, it is necessary (in all ways possible, including visuals and text) for their enticements to speak as directly as possible to their target audience. In the case of the predominantly African American owners whose signage Clements has documented, neither the methods nor the means must be too high-style or worldly for the customers they are intent on attracting. The signs must include an awareness of the ironic. Irony, or a combination of circumstances, or a result

that is the opposite of what might be expected or considered appropriate, is a large part of the aesthetic that informs African American images, ideas, and ideals. This sort of hip, tongue-in-cheek awareness of the unspoken grinds and gnashes of the economic realities of inner-city competition is often so subtle that it flies below the radar of casual or hurried observers.

This adventure of seeing and deducing the stories related by signs through their talking is made even more intriguing because of the dizzying combination of possible meaning and messages that reflect disparate commercial, religious, and patriotic interests.

The inner-city African American businesses recorded by Clements must often operate with financial handicaps, including poor capital, elevated insurance rates, and the high cost of wholesale goods bought in small quantities. And all this while trying to compete with the messiahs of mall culture located at the other end of the expressways. The competition has a leg up because of its professionally conceived, financed, and executed billboards which loom on the same or nearby buildings. One of the tales consistently told in *Talking Shops* is that the lure of the American dream of ownership overshadows the daunting rate of failure among independent inner-city entrepreneurs. Commercial enterprises continue to open, declare their existence, and state their dream of ultimate independence. This is the message that resonates in Clements's photographs, even when the businesses pictured have been stricken from the tax rolls and the signs are peeling, sun-faded, or weed-covered.

1

HAND-PAINTED STORE FRONTS

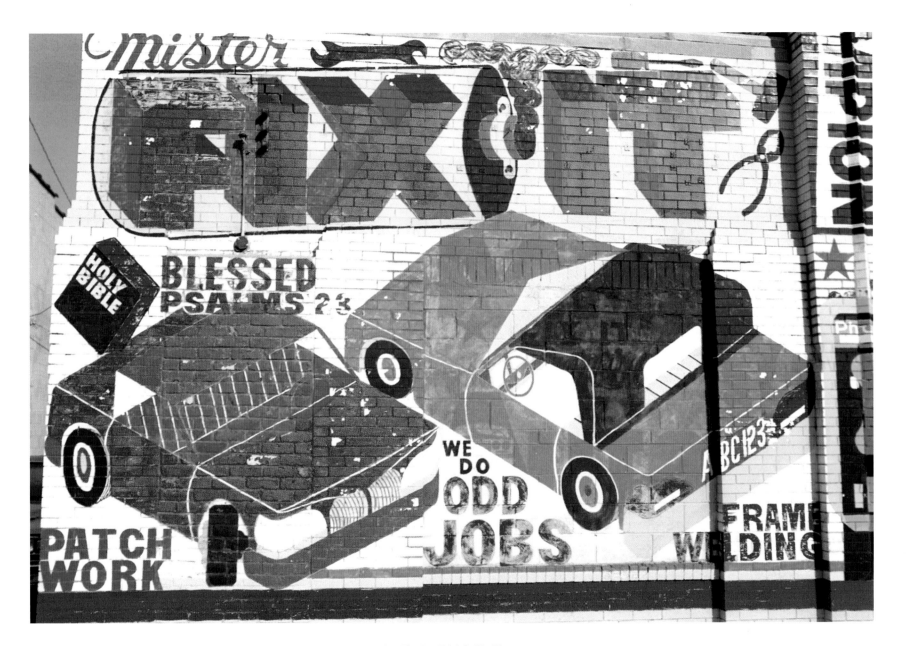

Mr. Fix-It, 5916 W. Warren

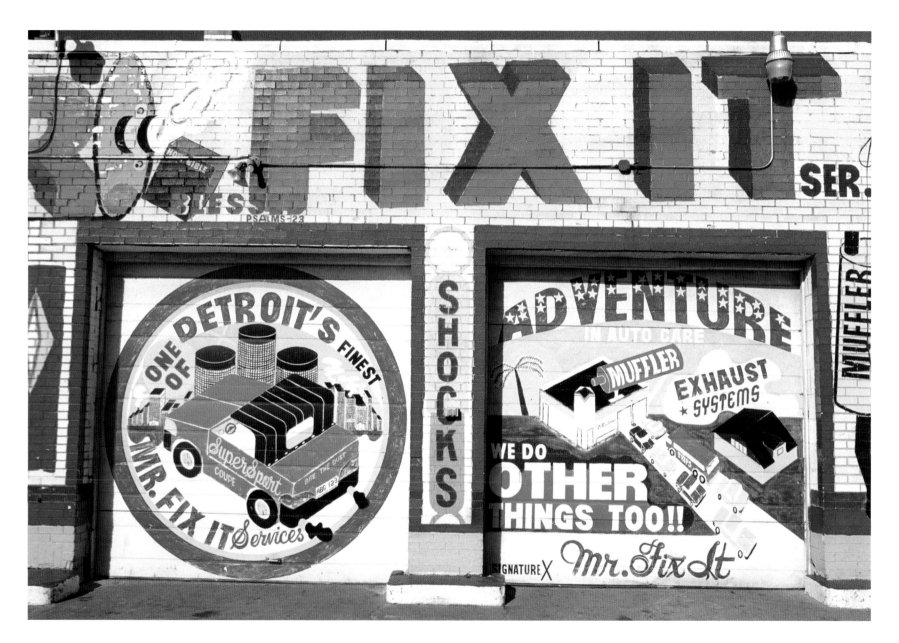

Mr. Fix-It, 5916 W. Warren

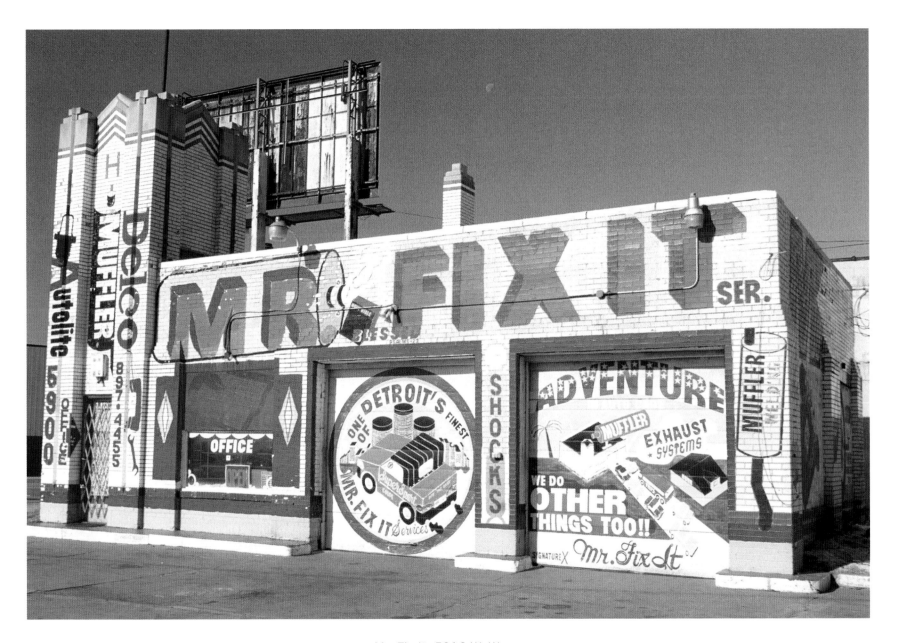

Mr. Fix-It, 5916 W. Warren

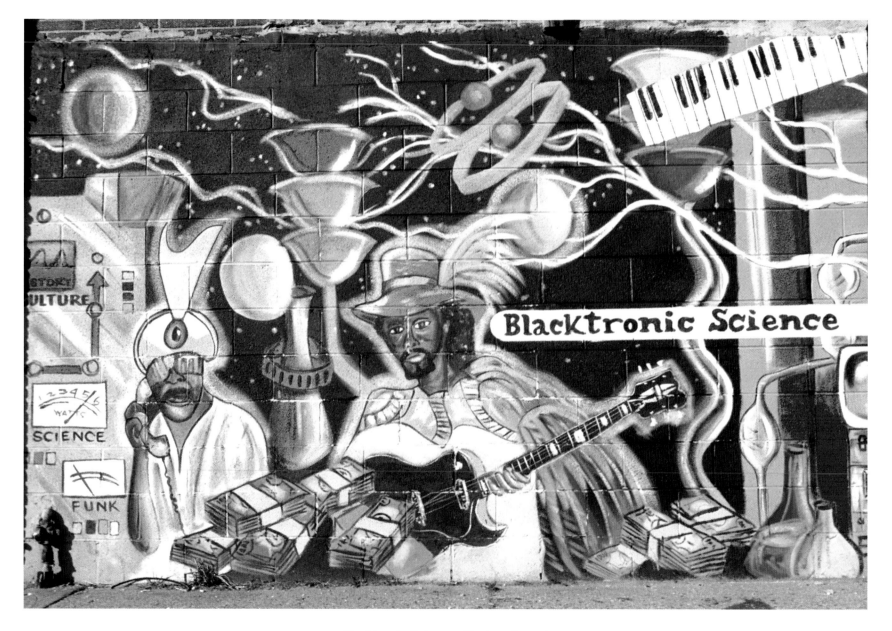

Blacktronic Science, Mack at Drexel

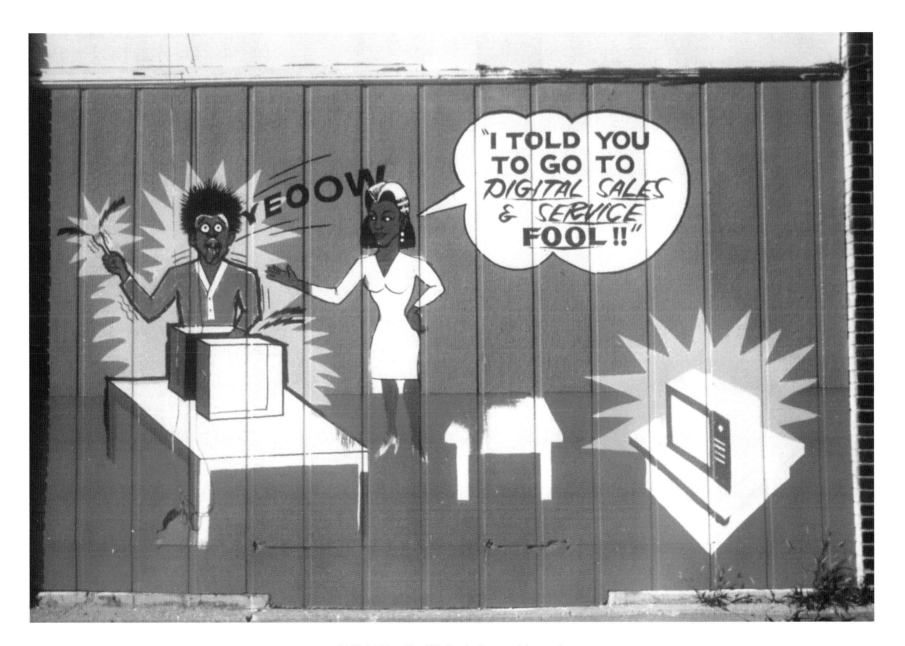

"I Told You Fool!" Fenkell near Livernois

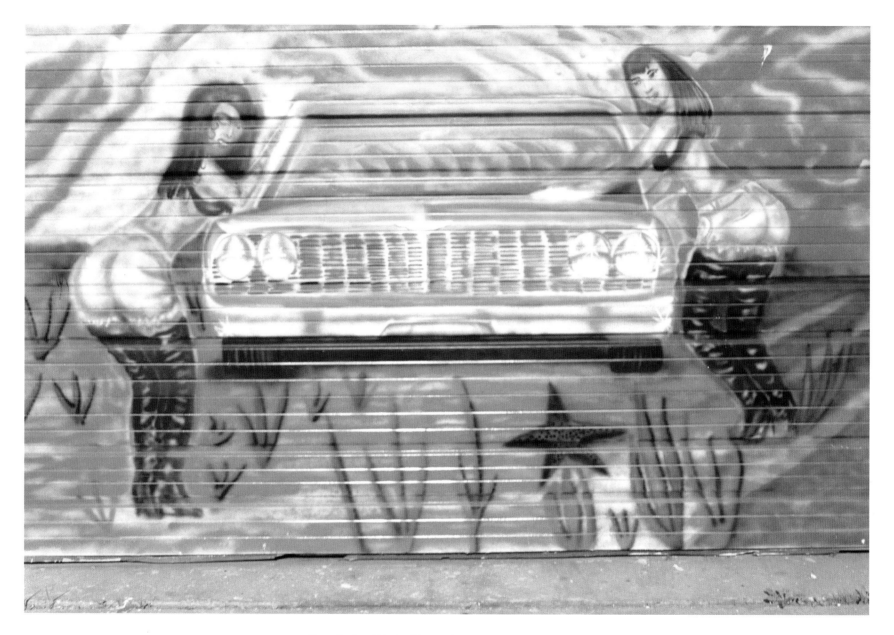

Pepp's Car Wash, Livernois north of Grand River

2

RELIGION

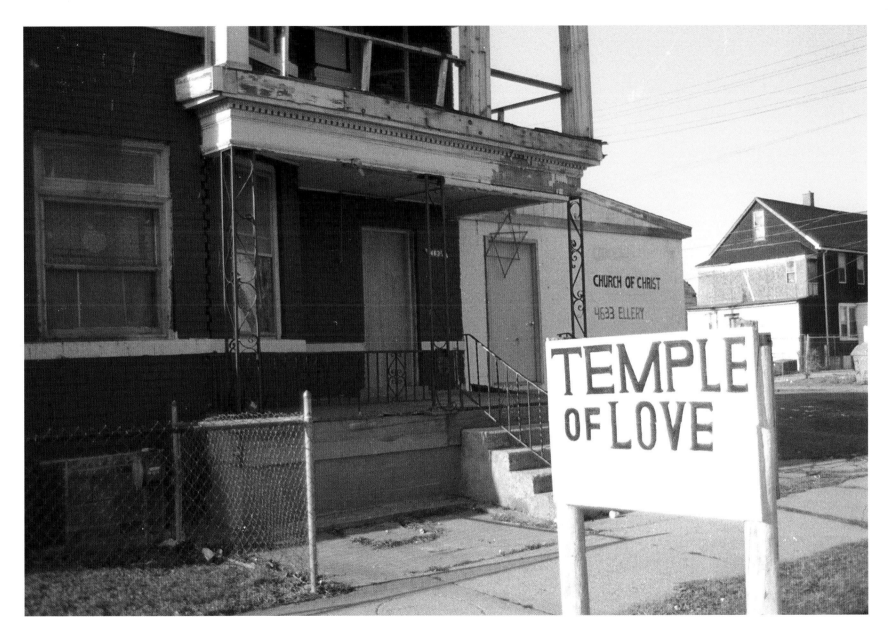

Temple of Love Church, 4635 Ellery

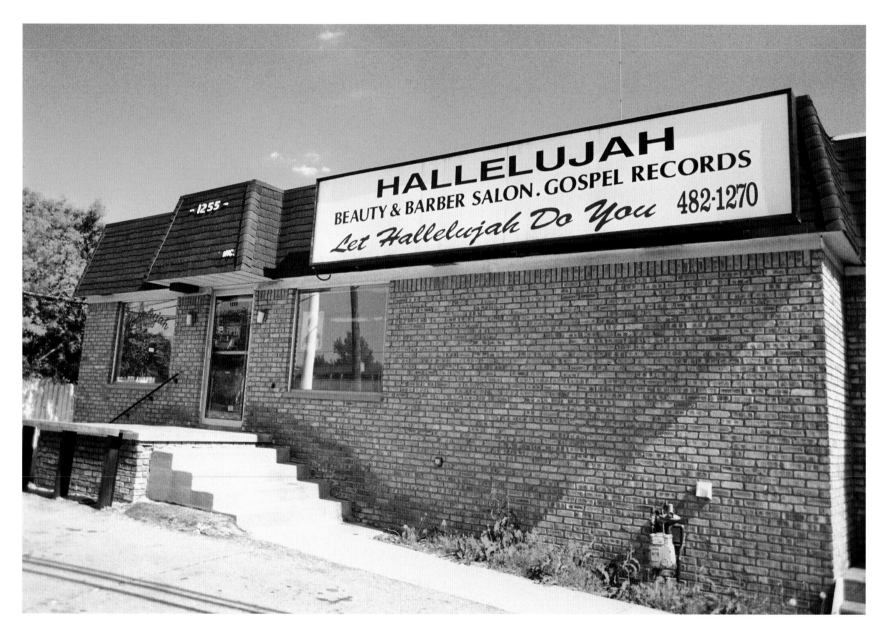

Hallelujah Beauty and Barber Salon and Gospel Records, Ypsilanti

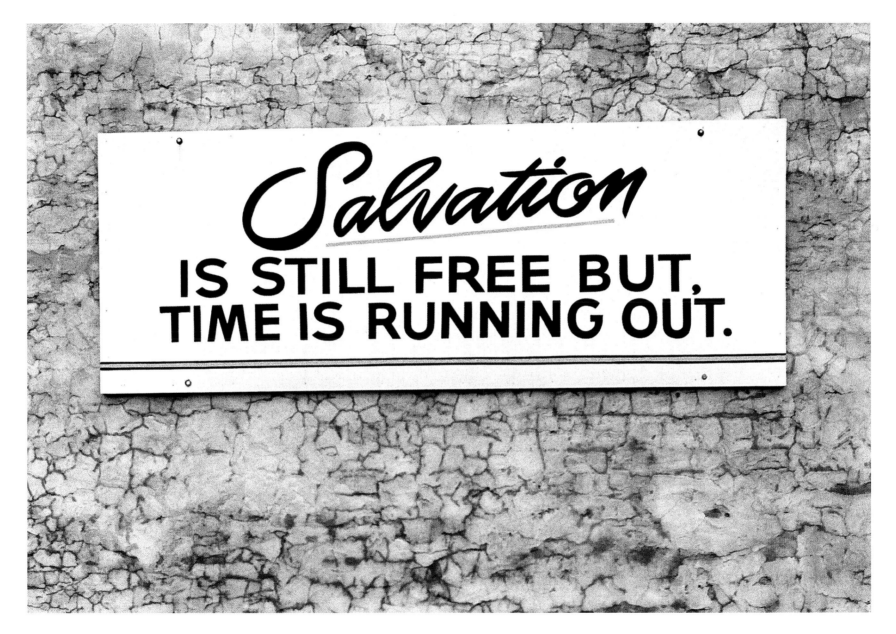

Salvation Is Still Free, location unknown

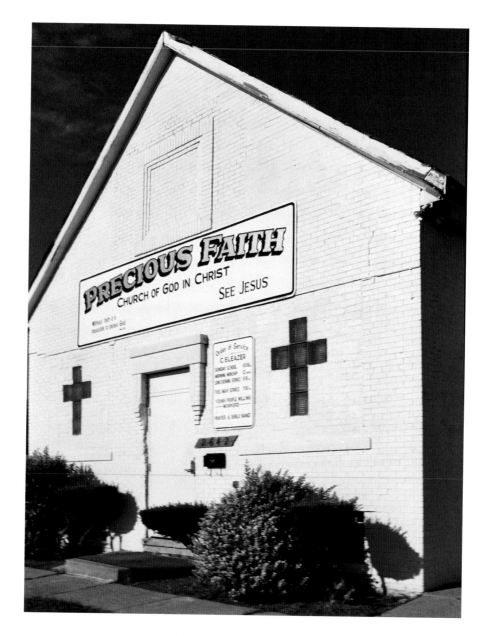

Precious Faith Church, 2642 Anderdon

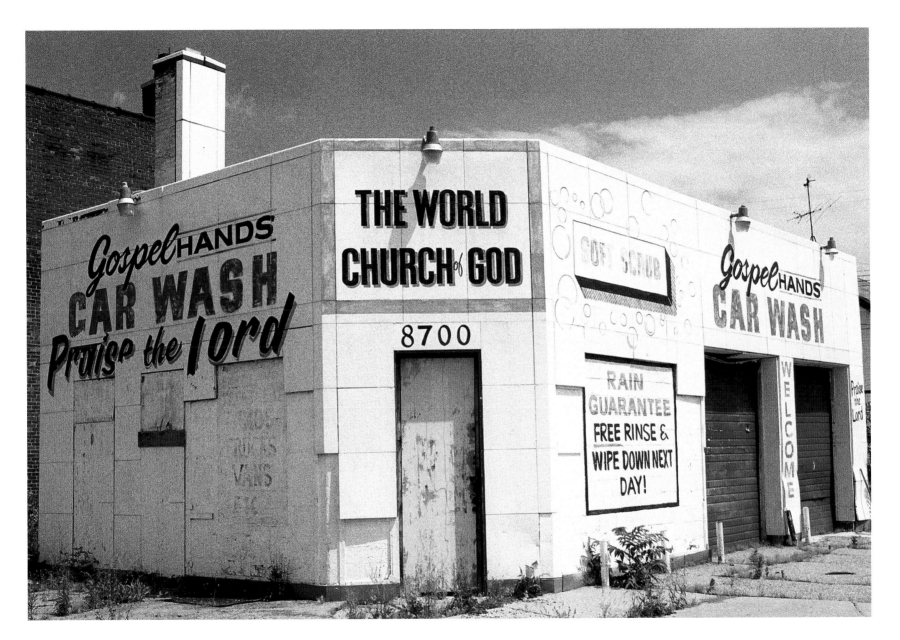

Gospel Hands Car Wash, 8700 E. Warren

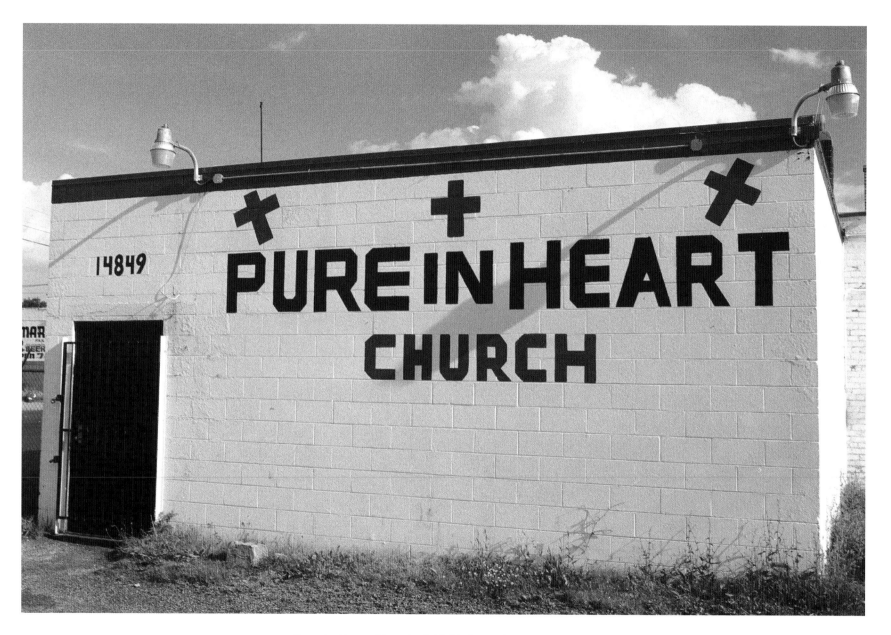

Pure in Heart Church, 14849 Schaefer near Fenkell

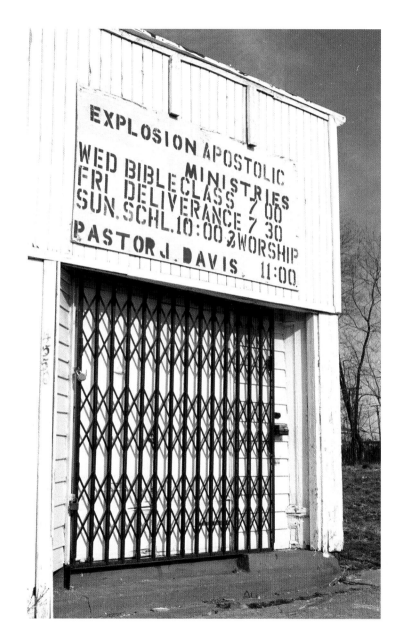

Explosion Apostolic Ministries, 4550 W. Warren

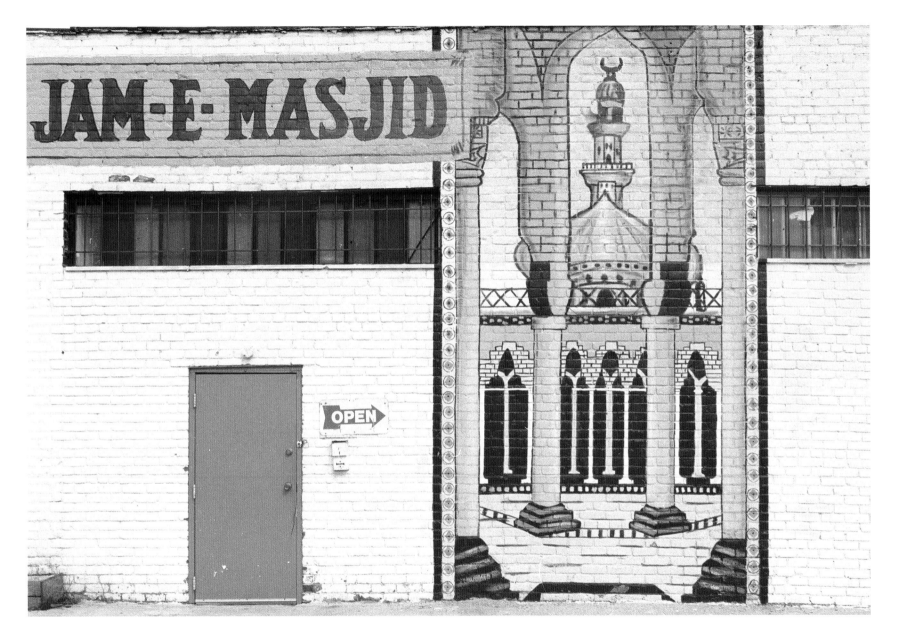

Bait-Ul-Jam-E-Masjid, Conant in Hamtramck

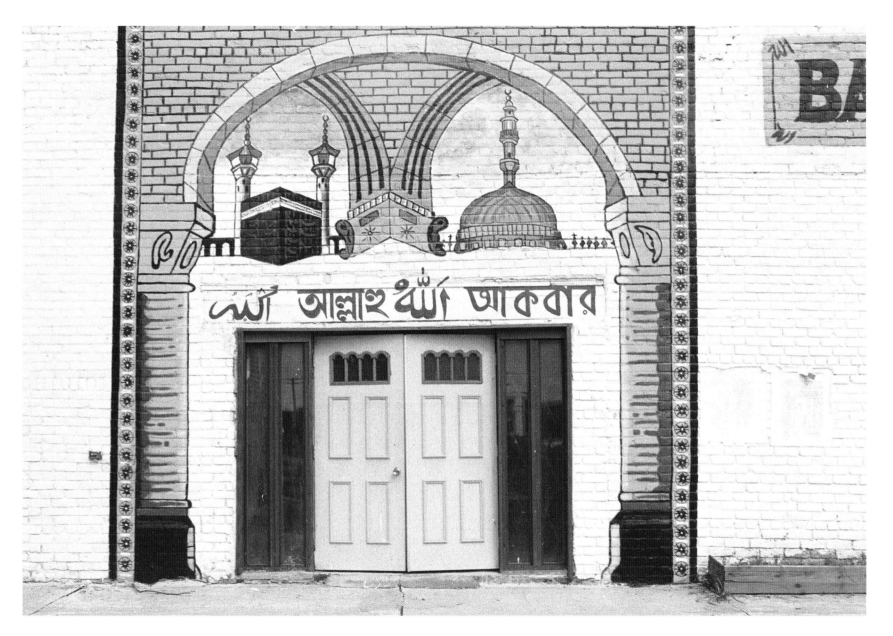

Bait-Ul-Jam-E-Masjid, Conant in Hamtramck

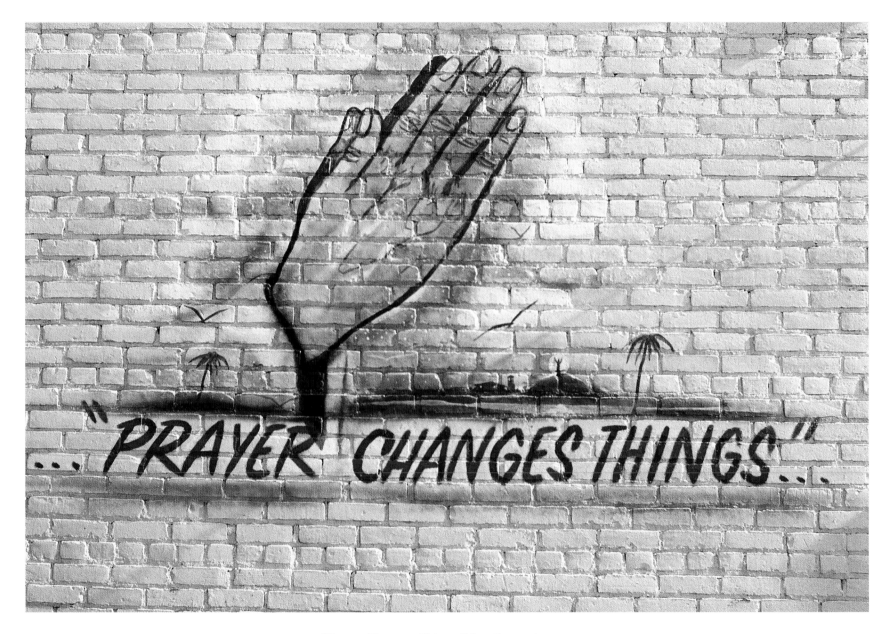

"Prayer Changes Things," location unknown

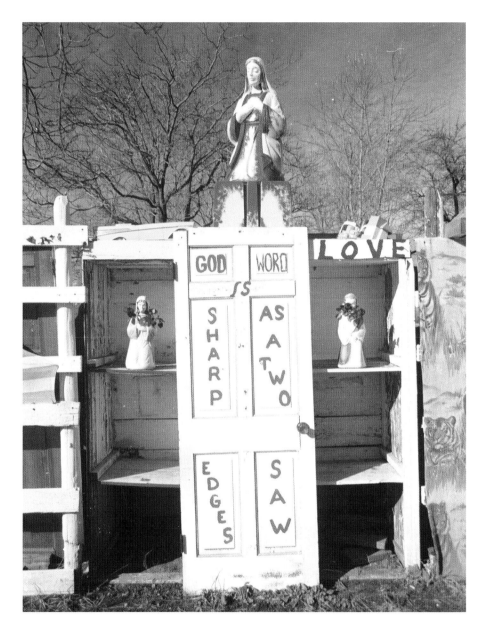

Two Edges Saw, Mitchell near Gratiot

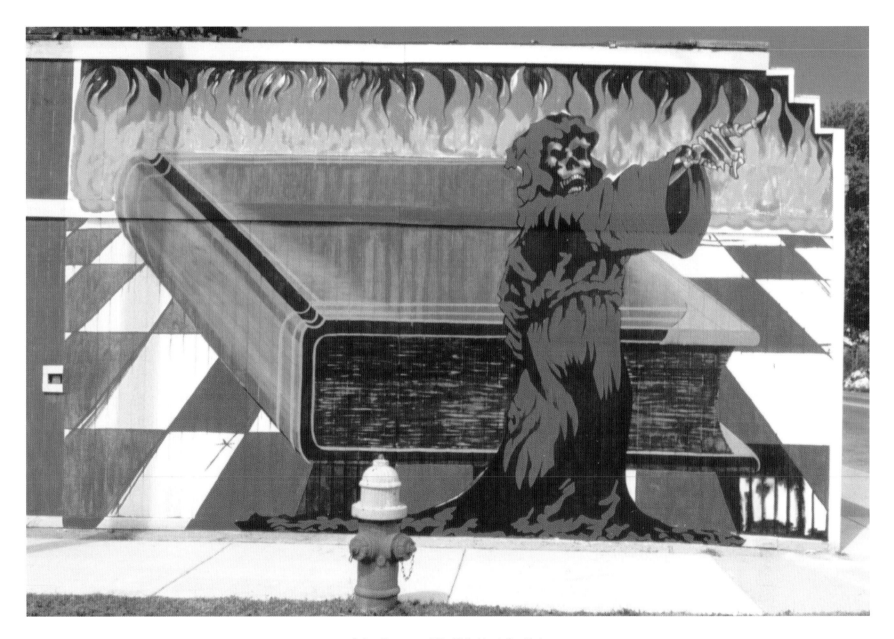

Grim Reaper, Mt. Elliott at Gratiot

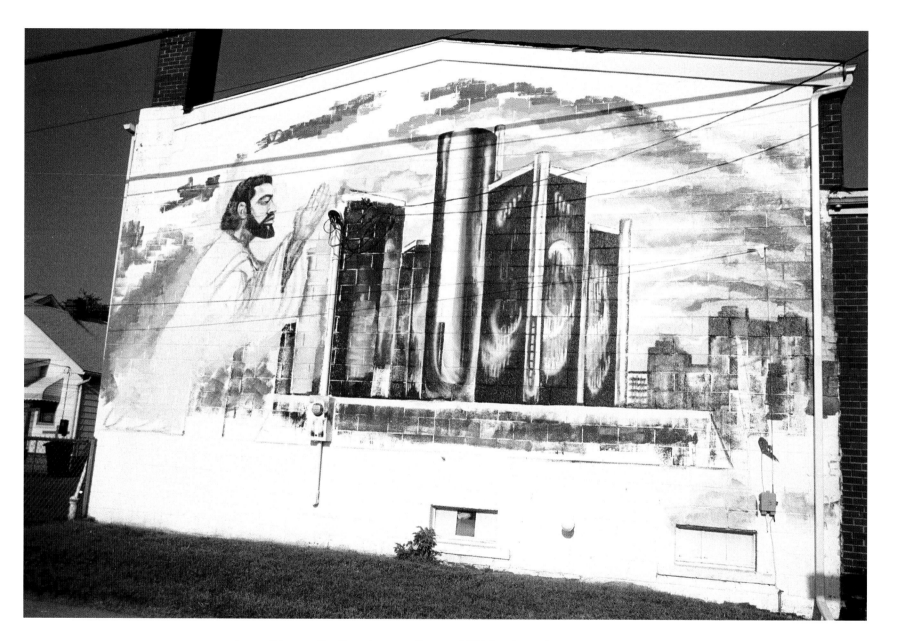

Jesus Blesses the Renaissance Center, I-75 Service Drive, south of 7 Mile

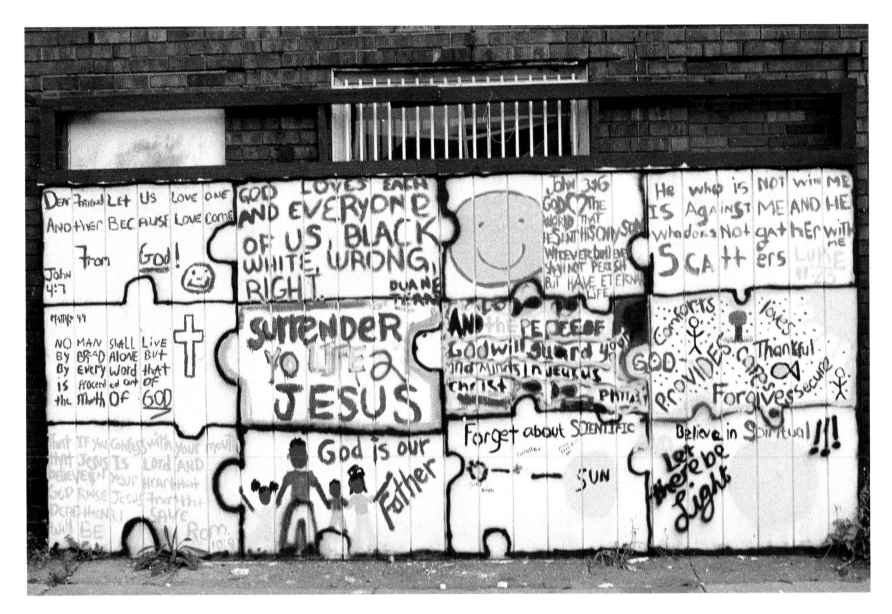

Religious Puzzle, Clairmont at Woodward

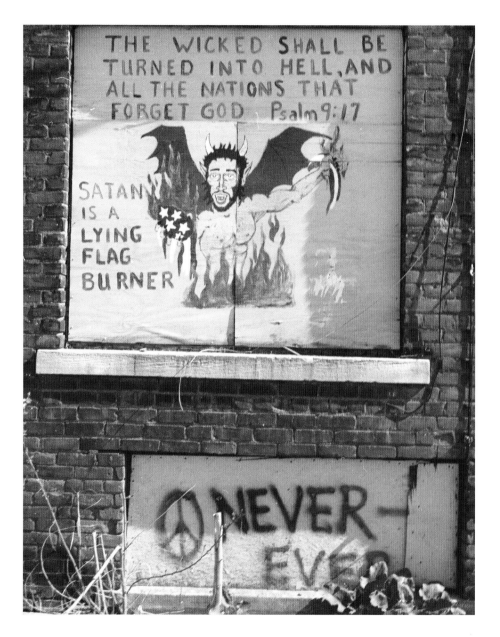

Satan Is a Lying Flag Burner, 2930 Cass

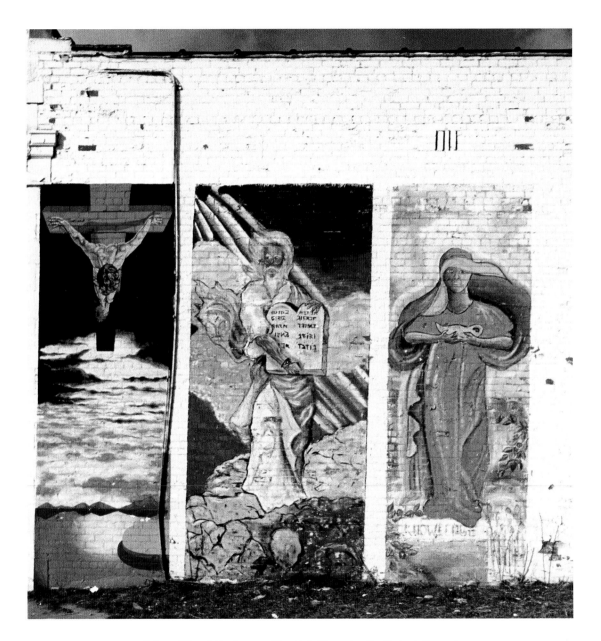

Silver Star Missionary Baptist Church, Gratiot at Forest

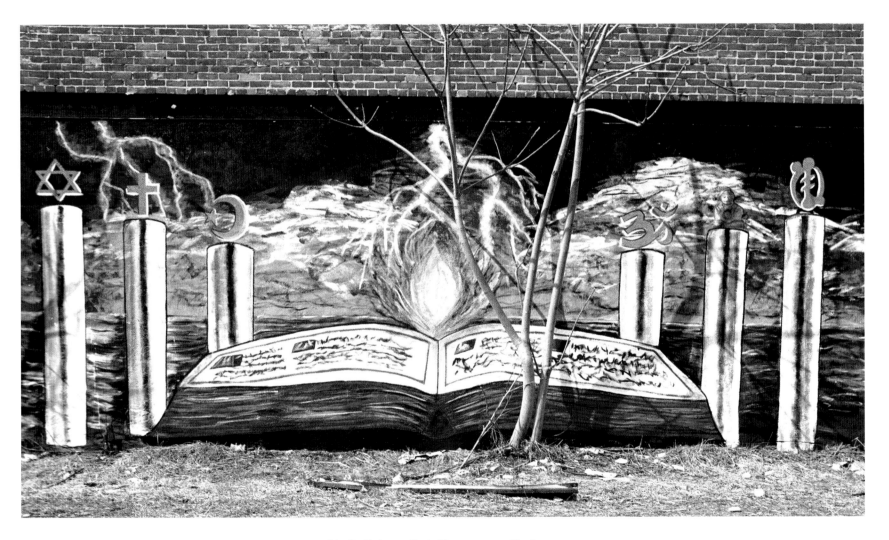

Six Religions, E. Jefferson near Chalmers

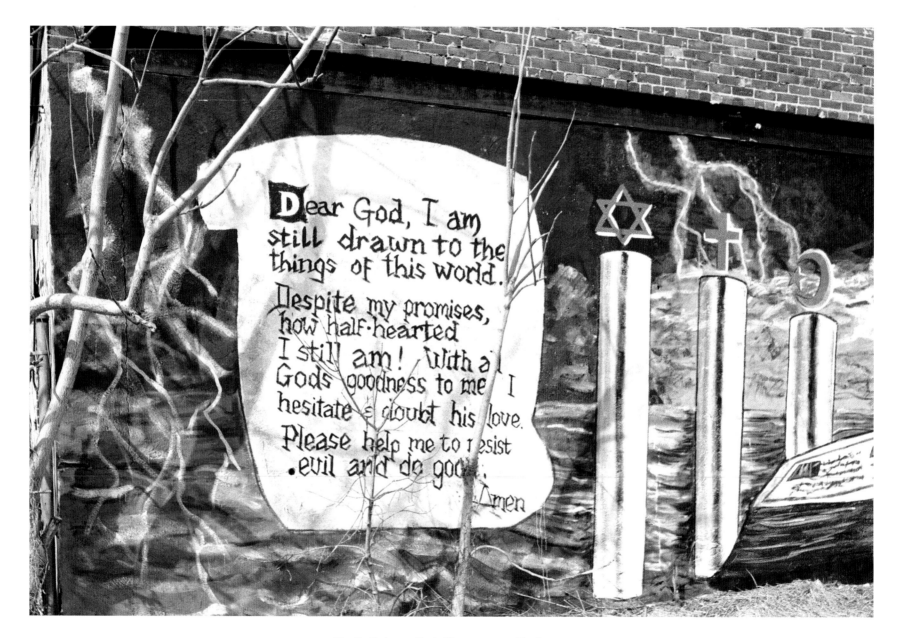

Six Religions, E. Jefferson near Chalmers

3

TEXT ADVERTISING

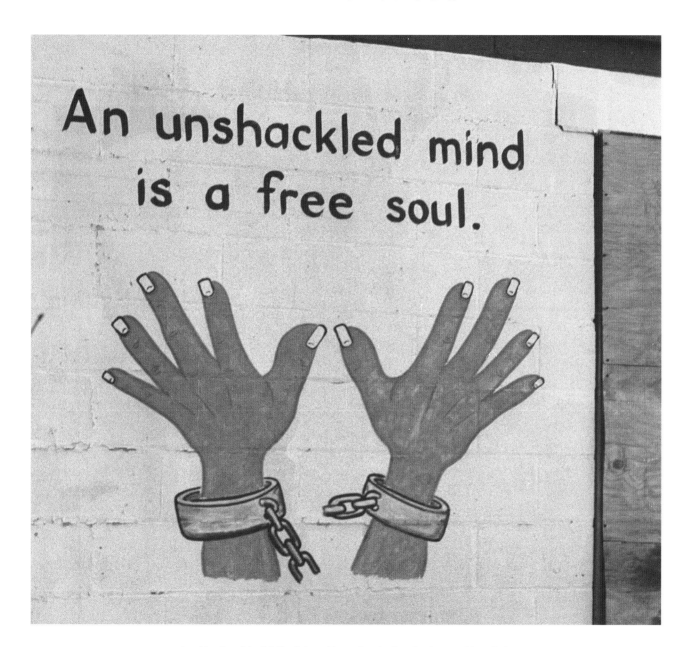

An Unshackled Mind Is a Free Soul, St. Cyrl near Van Dyke

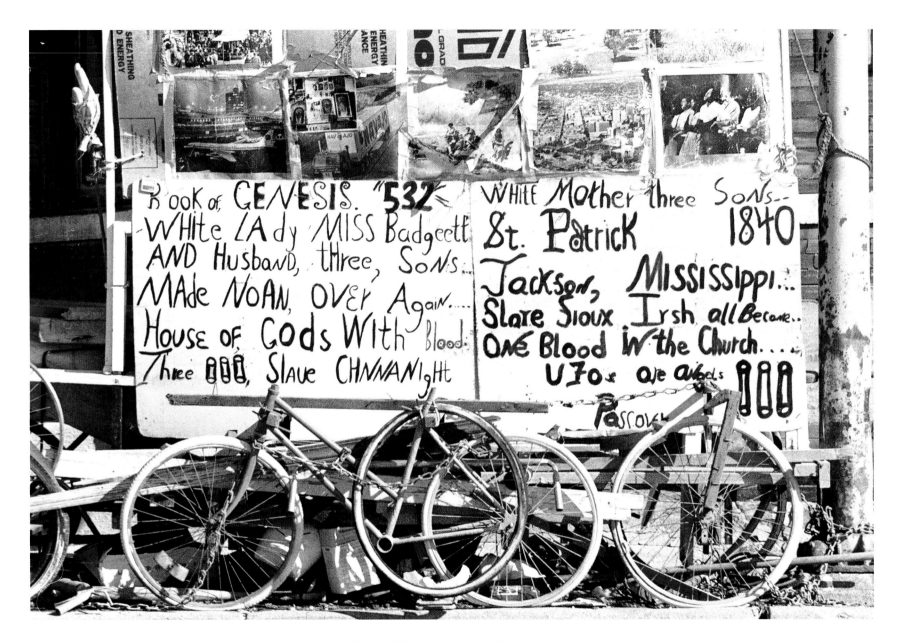

Book of Genesis, Brush at Erskine

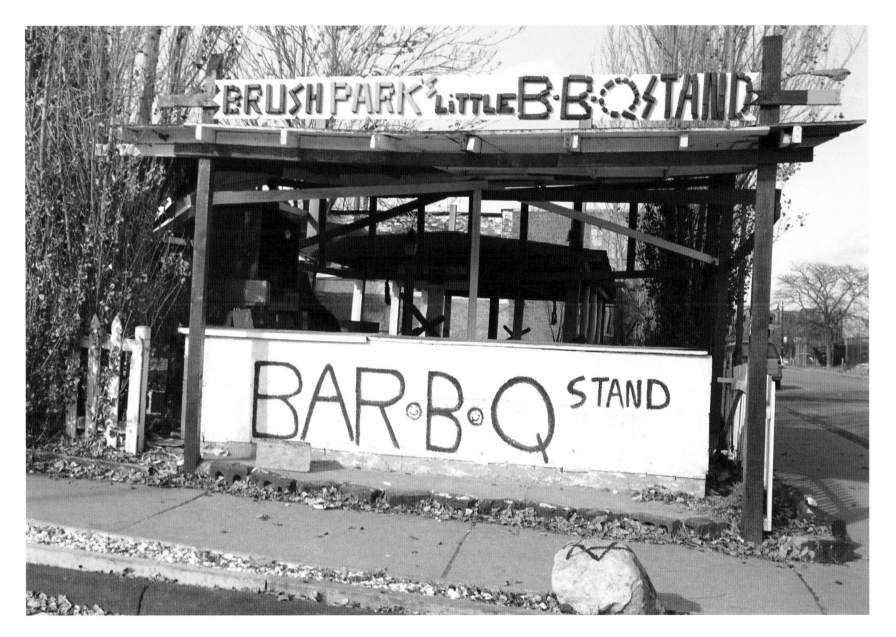

Brush Park's Little Bar-B-Q Stand, Brush at Erskine

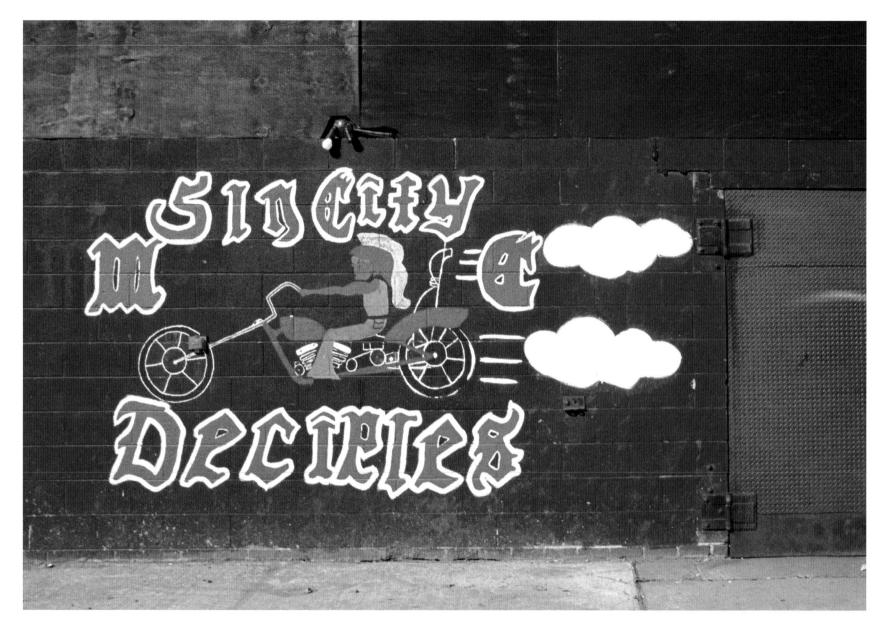

Sin City Disciples Motor Cycle Club, 8929 W. Warren

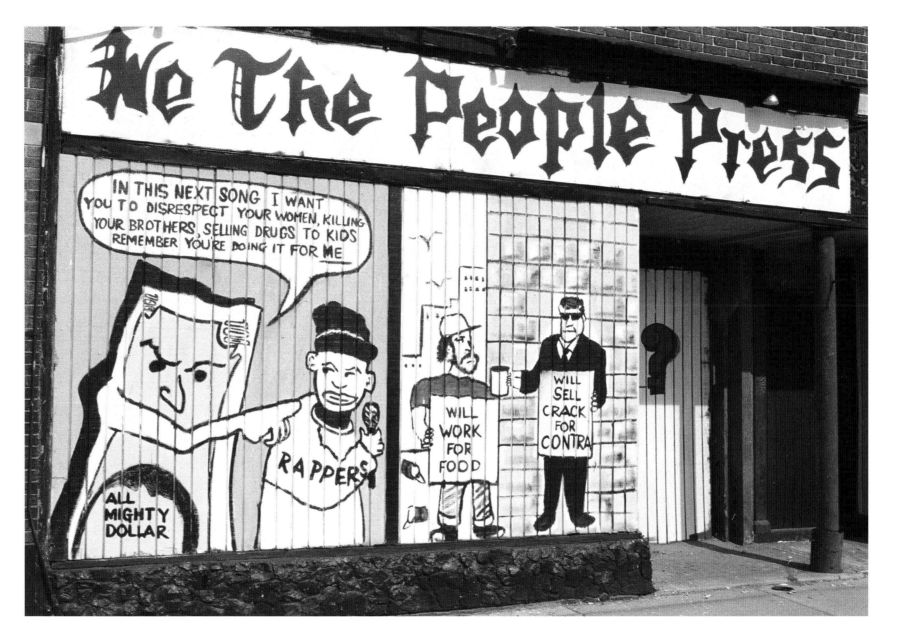

We the People, E. Jefferson near Chalmers

4

ANIMALS

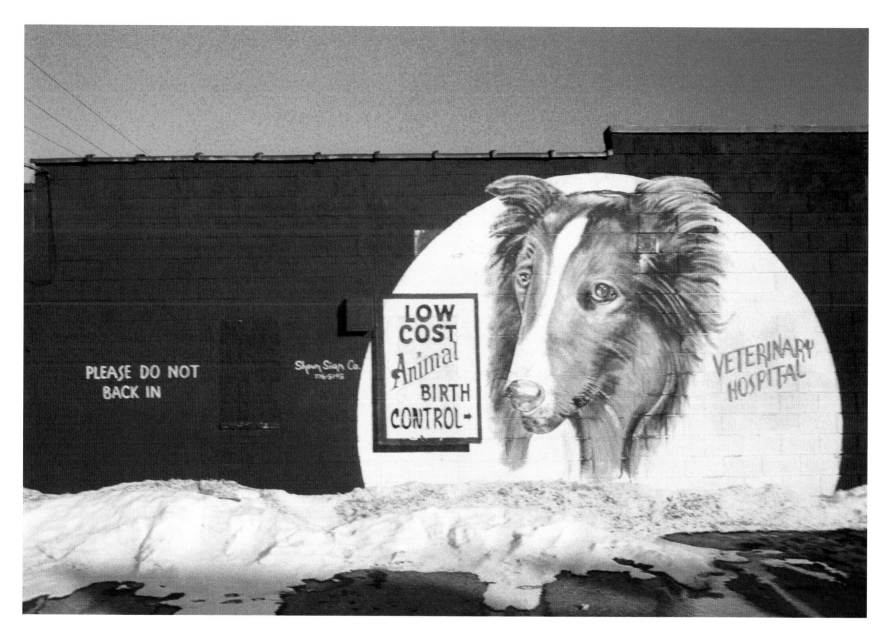

Animal Birth Control, 531 E. 8 Mile

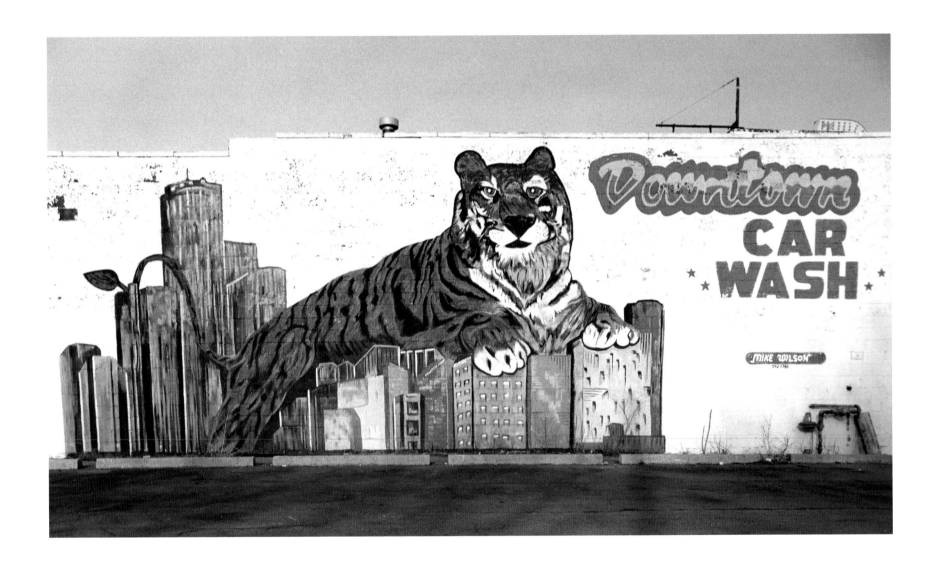

Downtown Car Wash, 1237 Michigan Ave.

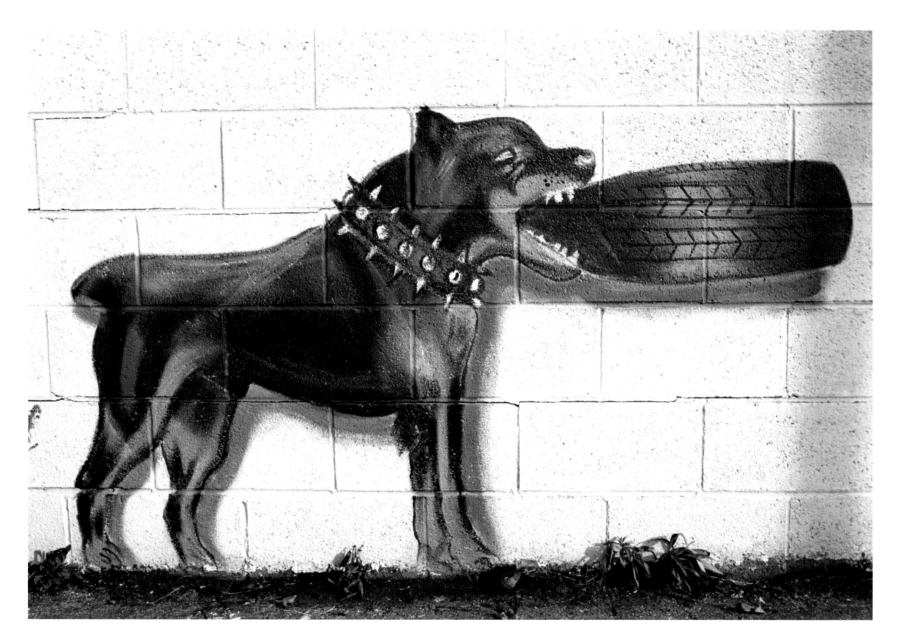

We Fix Flats, 3031 Gratiot

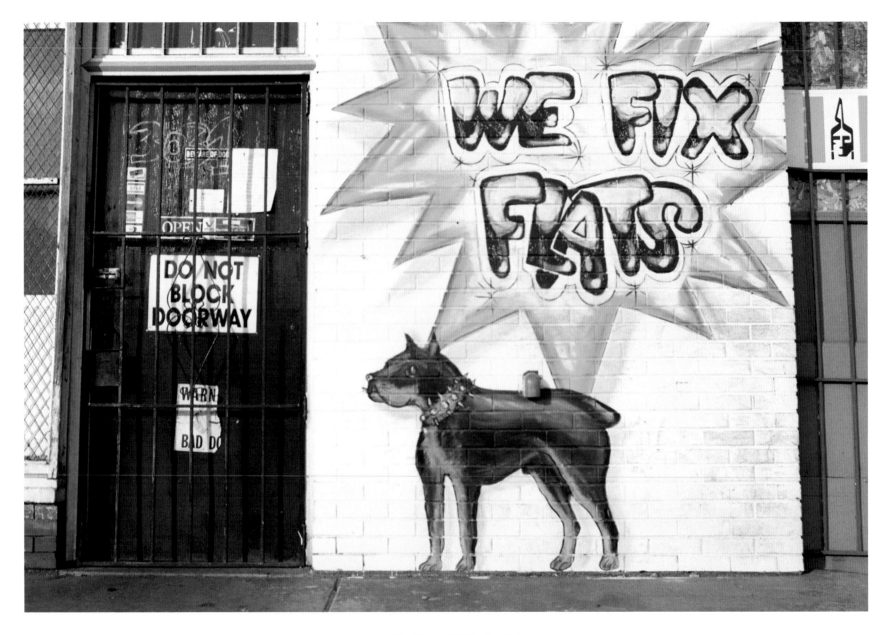

We Fix Flats, 3031 Gratiot

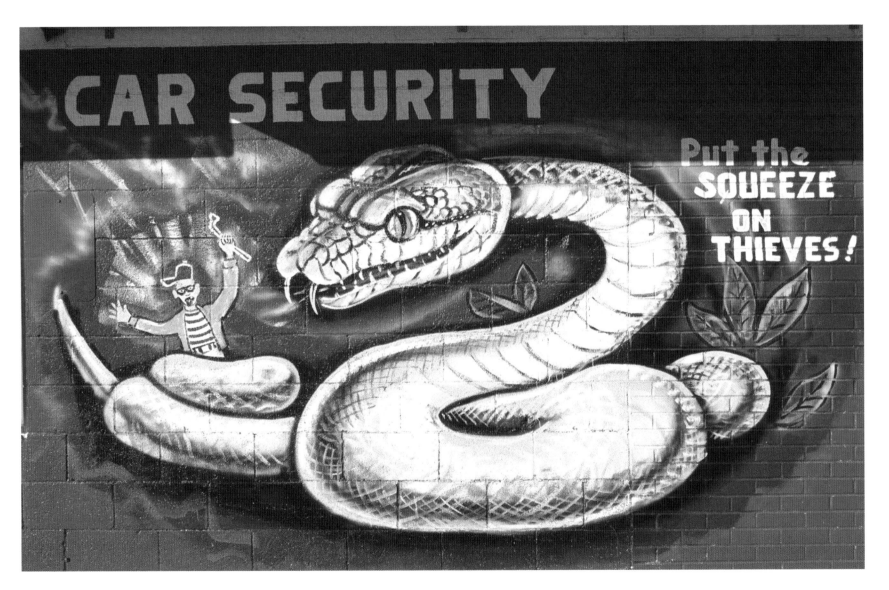

Put the Squeeze on Thieves, Car Security, 14711 W. 8 Mile

5

AUTOMOBILES

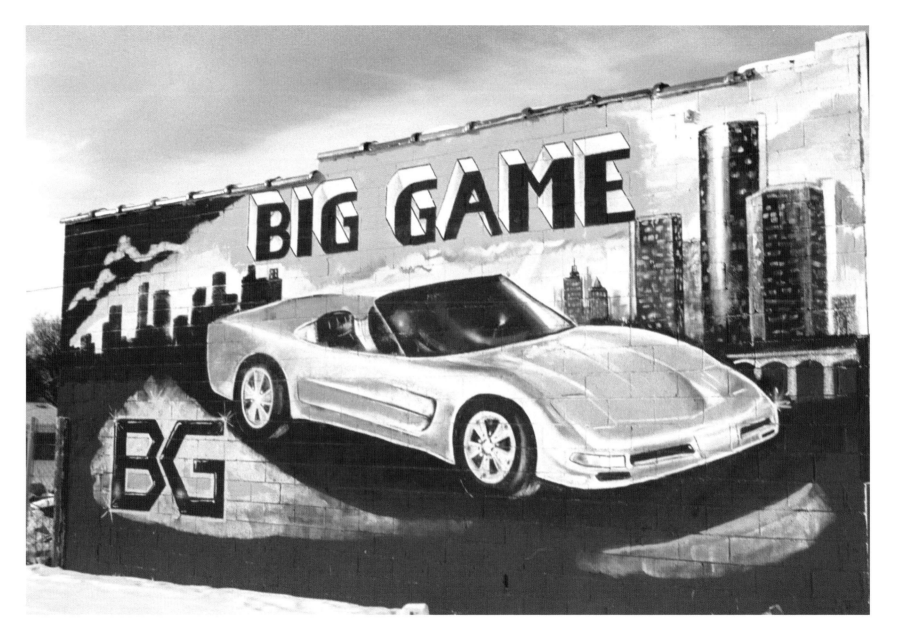

Big Game Car Wash, 10337 W. 8 Mile

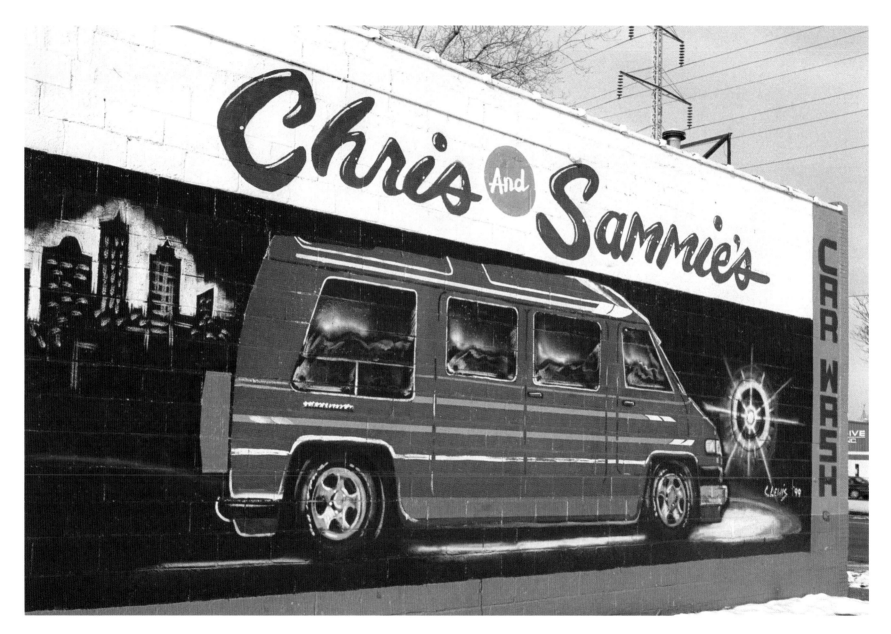

Chris and Sammie's Car Wash, 13105 W. 8 Mile

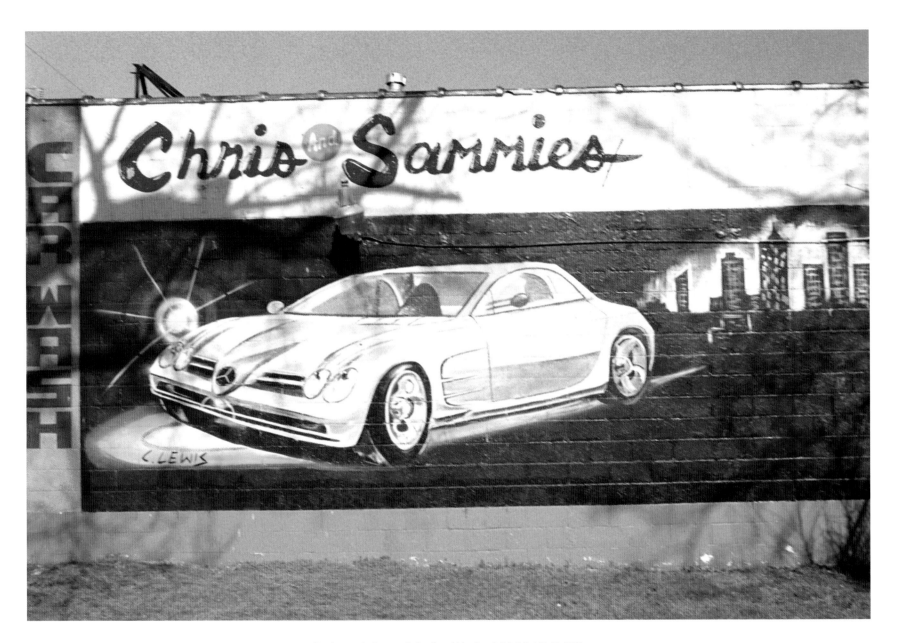

Chris and Sammie's Car Wash, 13105 W. 8 Mile

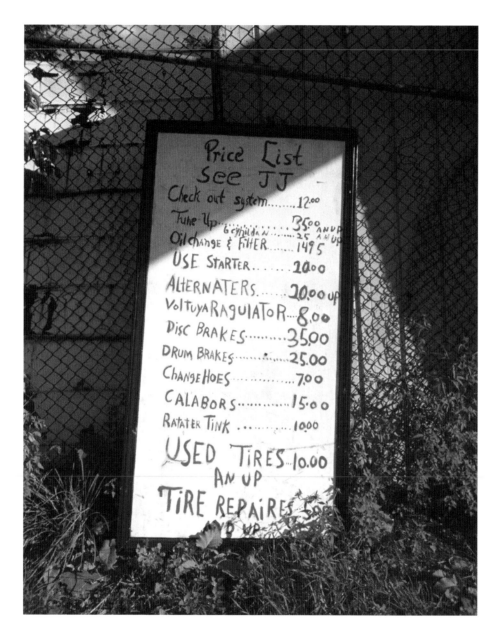

J.J's Price List, Victor near Oakland

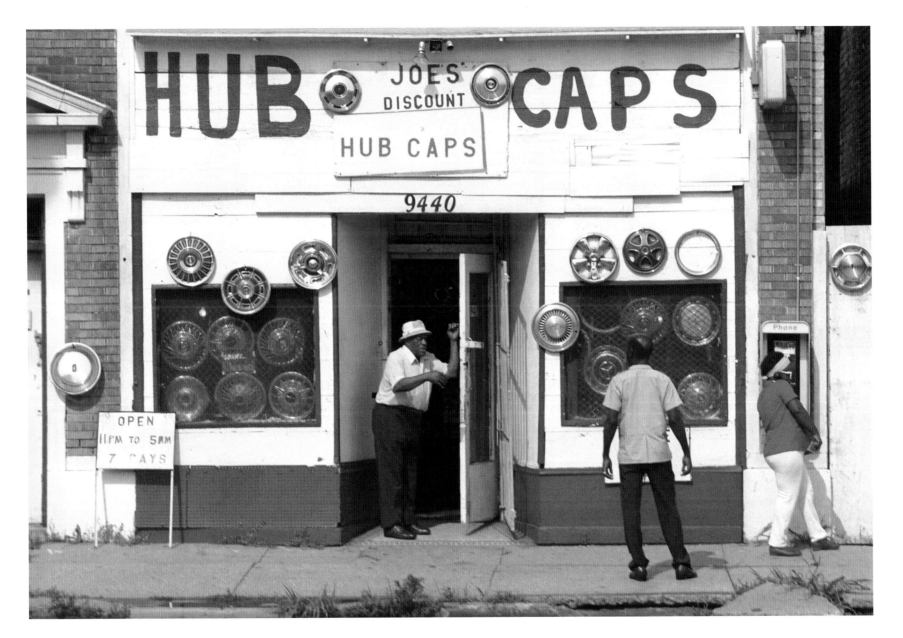

Joe's Hub Caps, 9440 Woodward

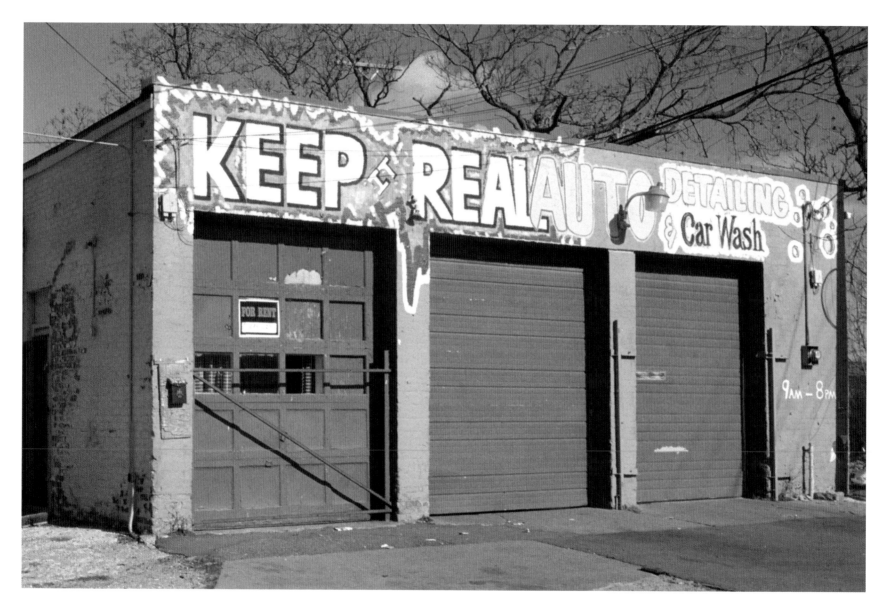

Keep It Real Auto Detailing and Car Wash, 5000 E. Forest

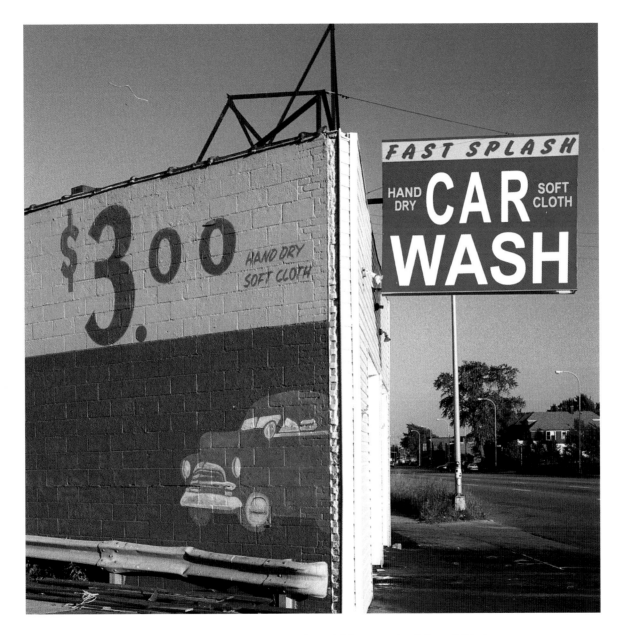

Fast Splash Car Wash, Grand River south of Grand Blvd.

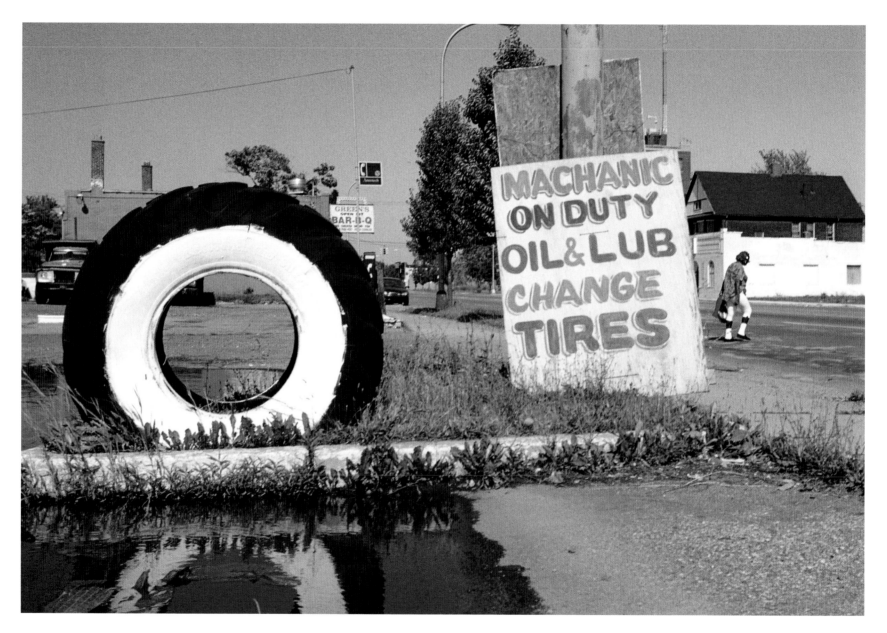

Mechanic on Duty, Oil and Lube, 2970 W. Warren

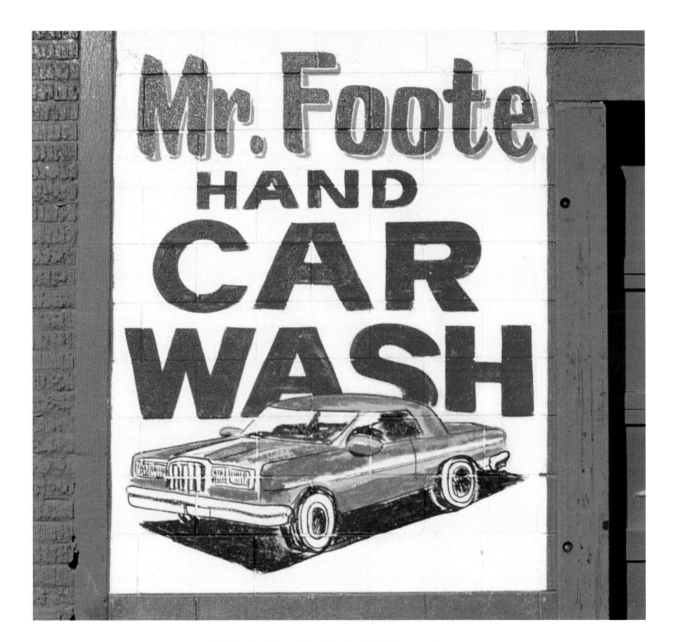

Mr. Foote Hand Car Wash, Gratiot near Connor

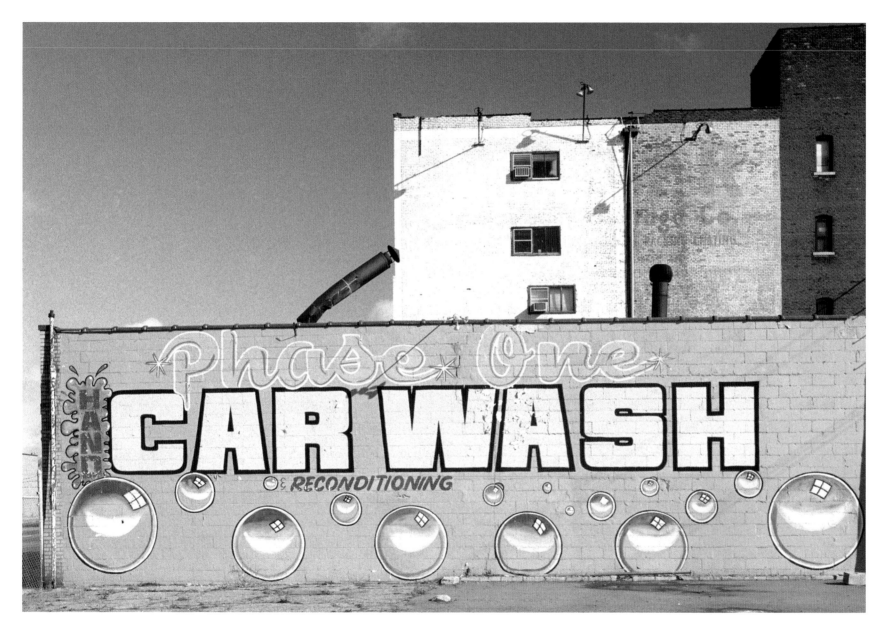

Phase One Car Wash, 7714 Gratiot

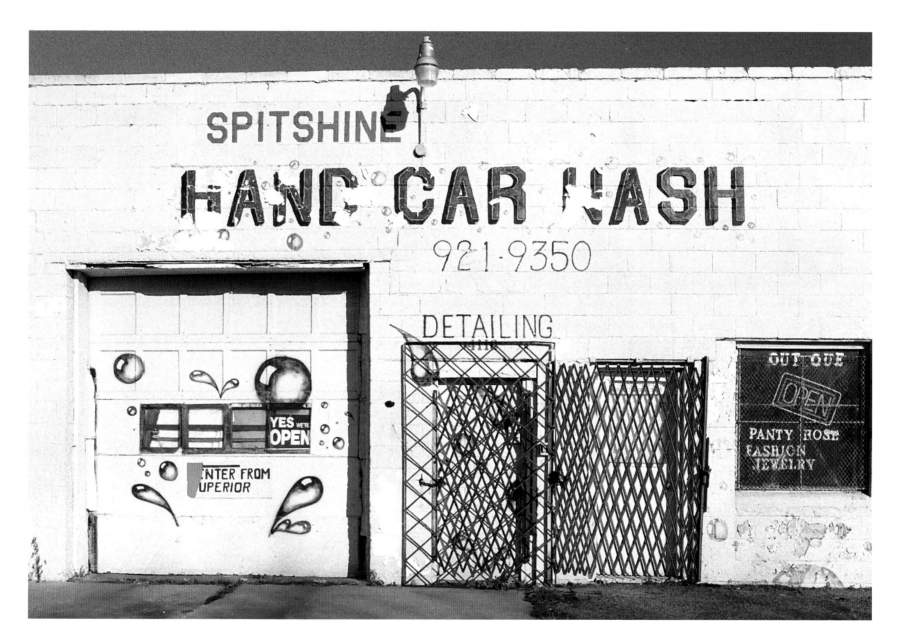

Spitshine Car Wash, 4118 Chene

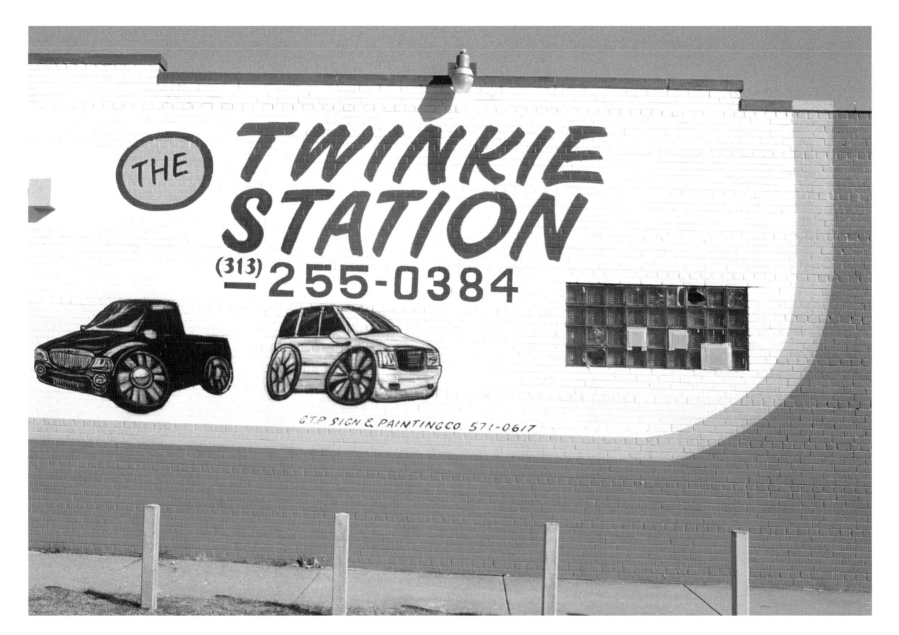

The Twinkie Station, 19541 W. 7 Mile near Greenfield

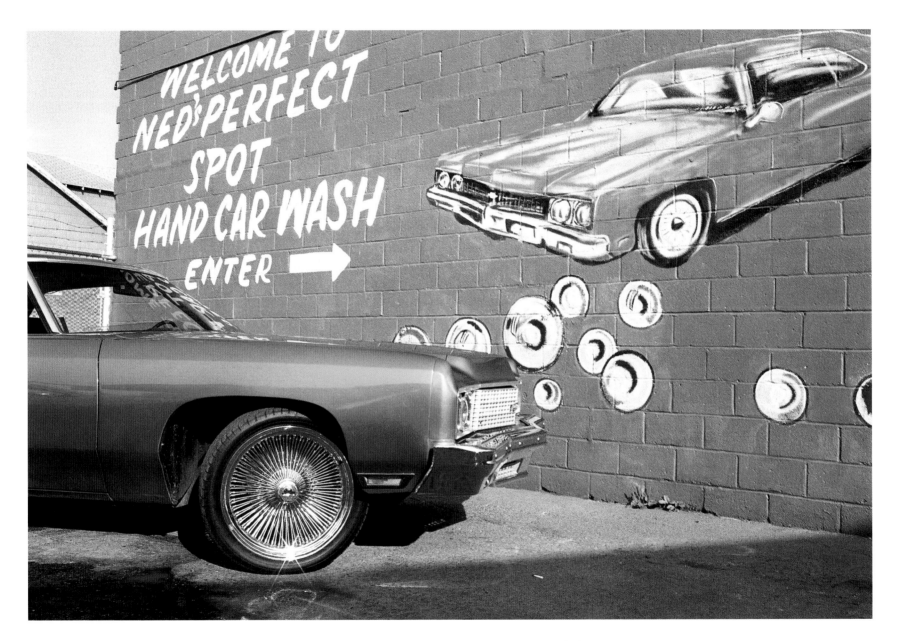

Ned's Perfect Spot Car Wash, Van Dyke south of Harper

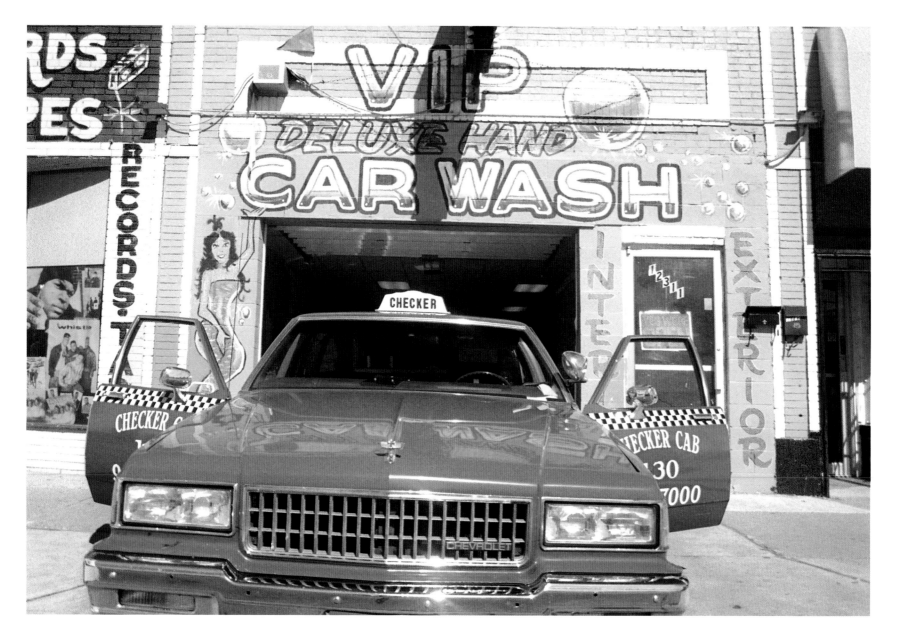

VIP Car Wash, 12311 Gratiot

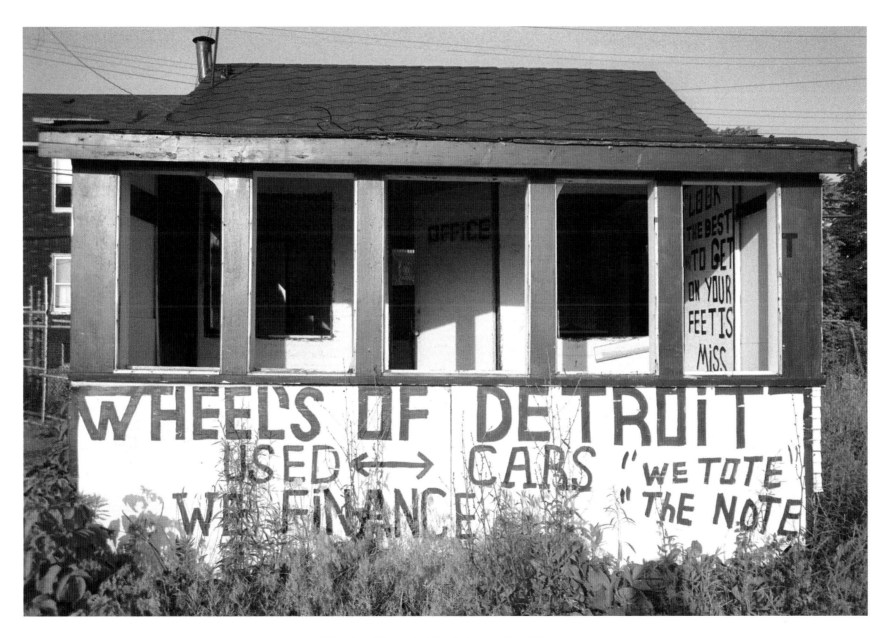

Wheels of Detroit, Van Dyke south of Harper

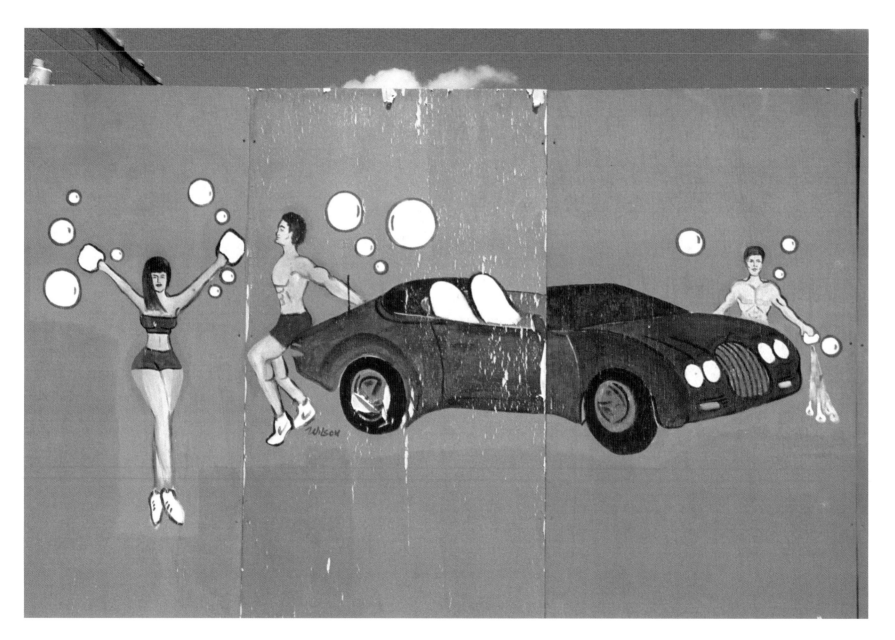

Yetta Boo's, 10444 Joy

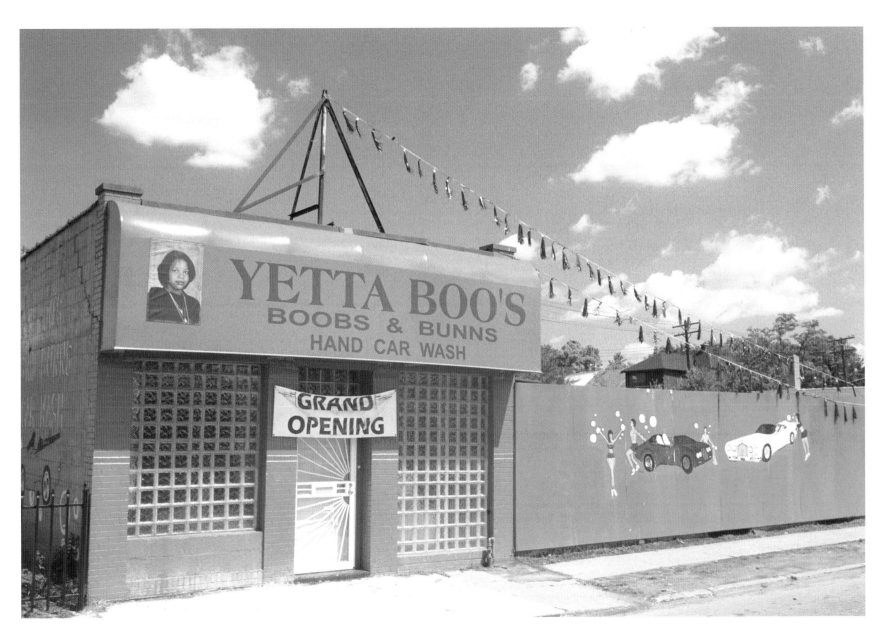

Yetta Boo's, 10444 Joy

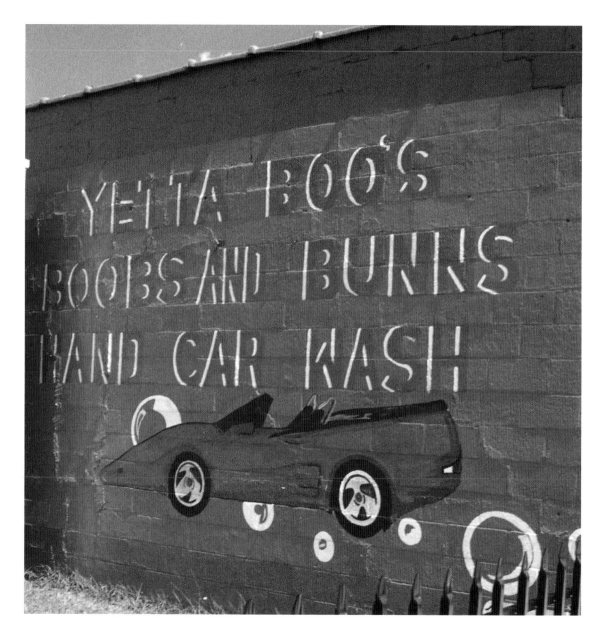

Yetta Boo's, 10444 Joy

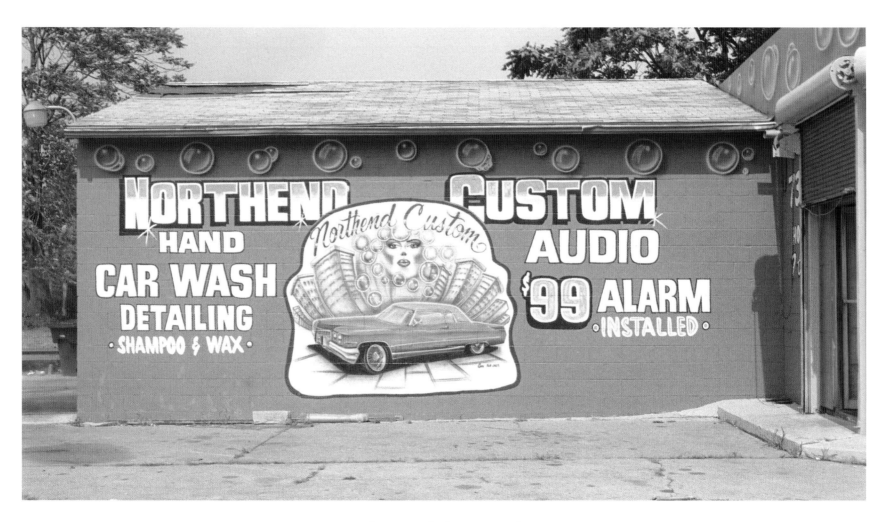

Northend Custom, 7340 John R at Grand Blvd.

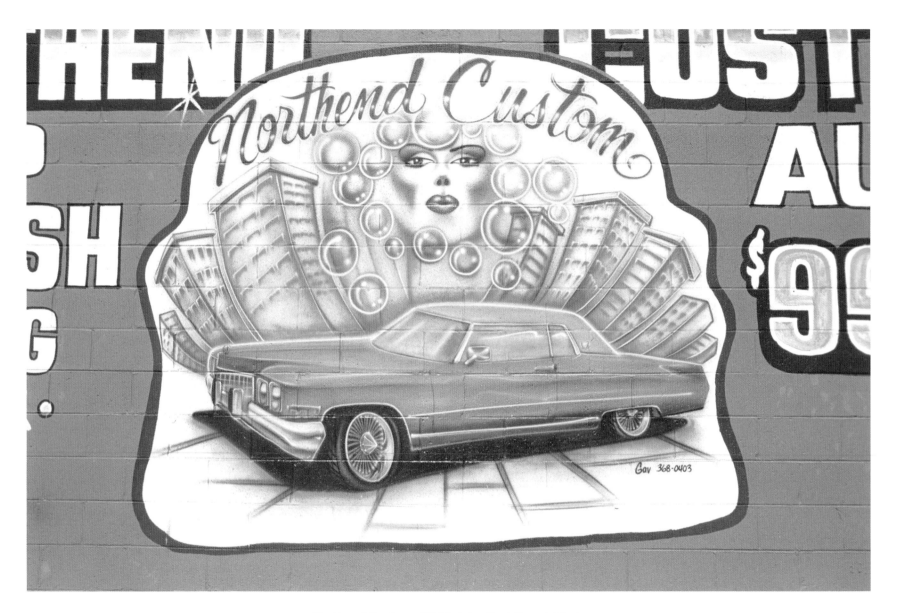

Northend Custom, 7340 John R at Grand Blvd.

6

PORTRAITS

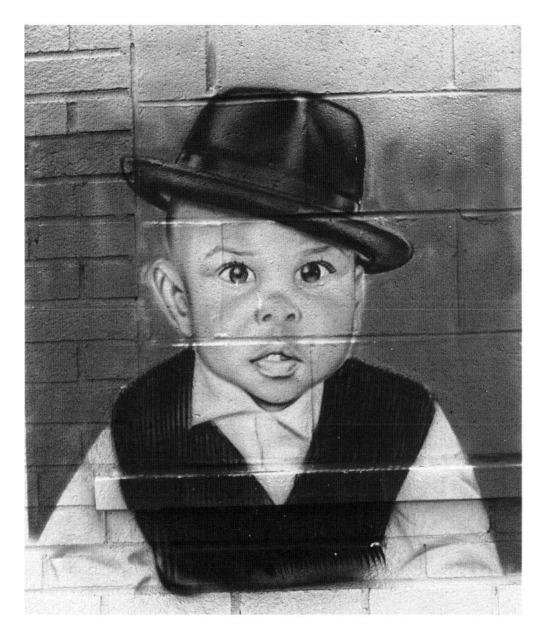

Boy, E. McNichols near Conant

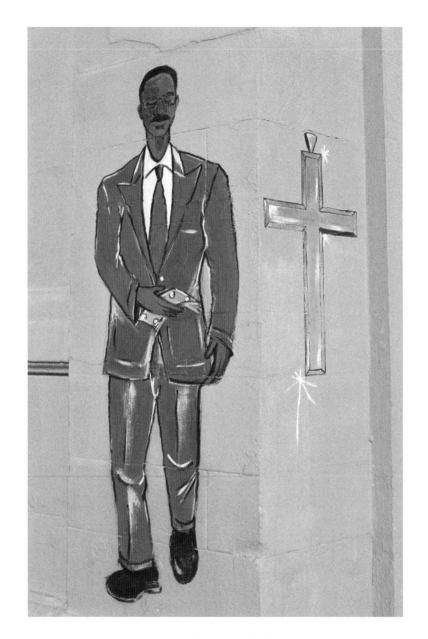

Gold Mine Man, 6301 Gratiot

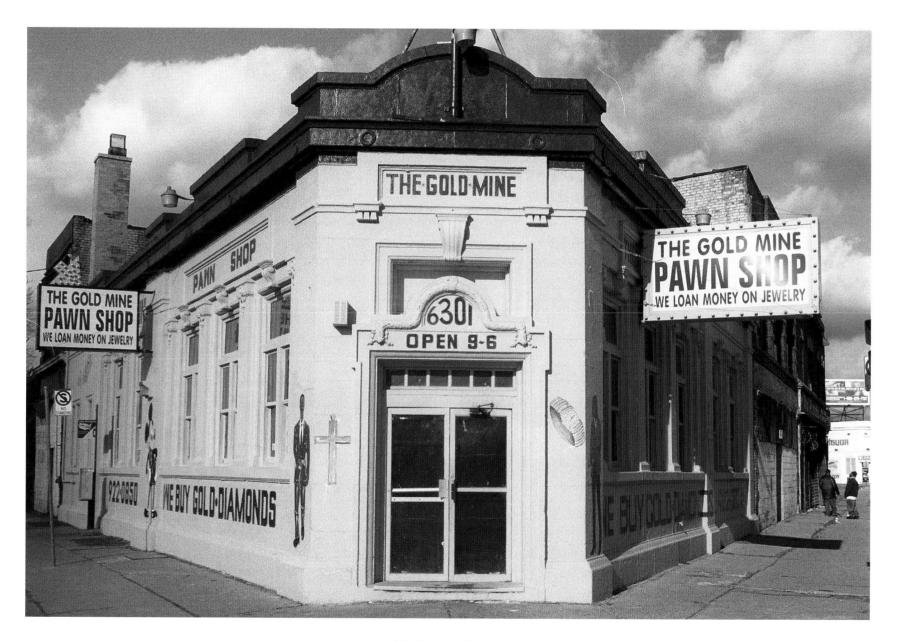

Gold Mine, 6301 Gratiot

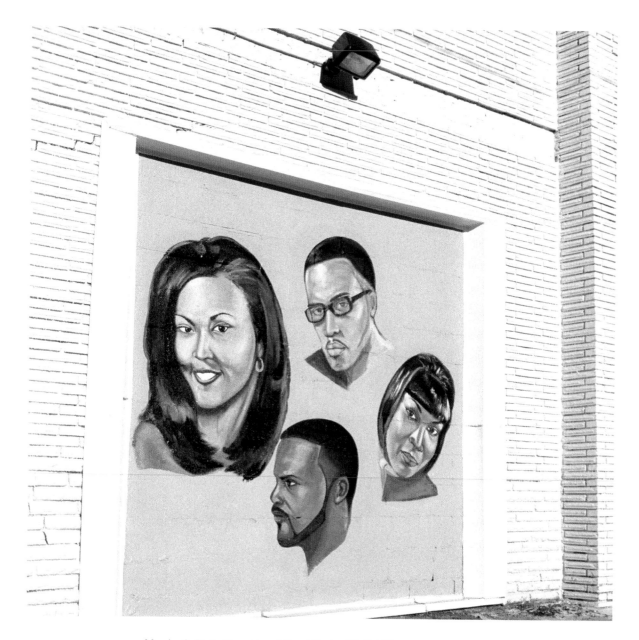

Music & Detailing Hand Car Wash, W. 7 Mile near Wyoming

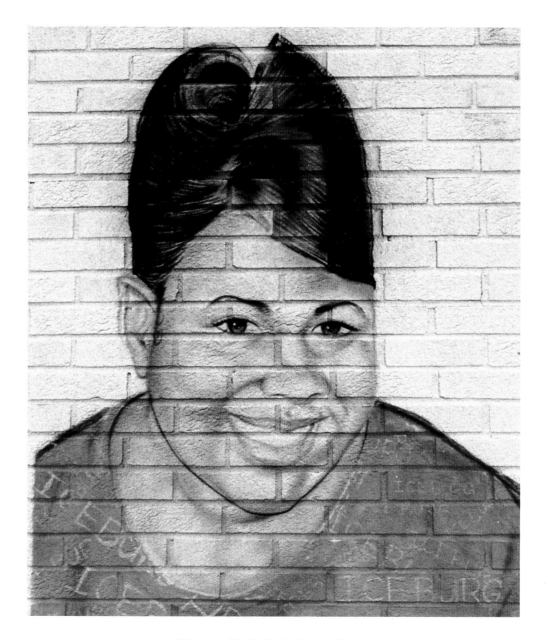

Woman, E. McNichols near Conant

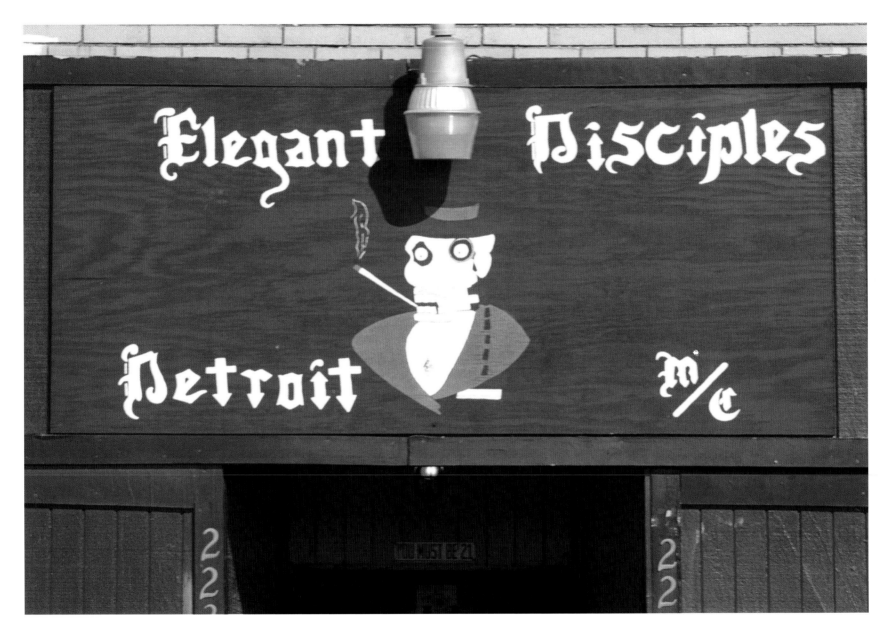

Elegant Disciples, 2231 E. Davidson

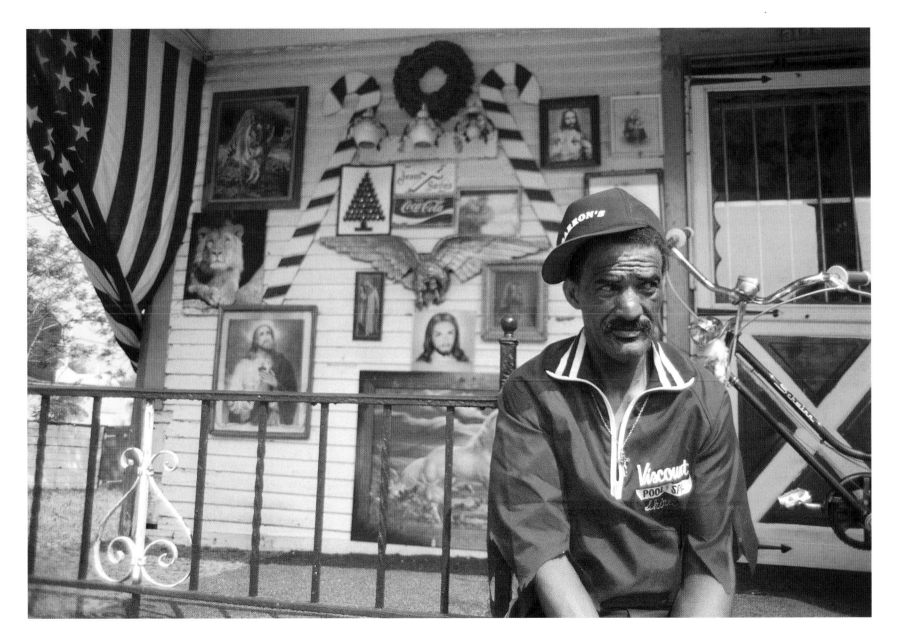

Front Porch, Mitchell near Gratiot

7

MERCHANDISE

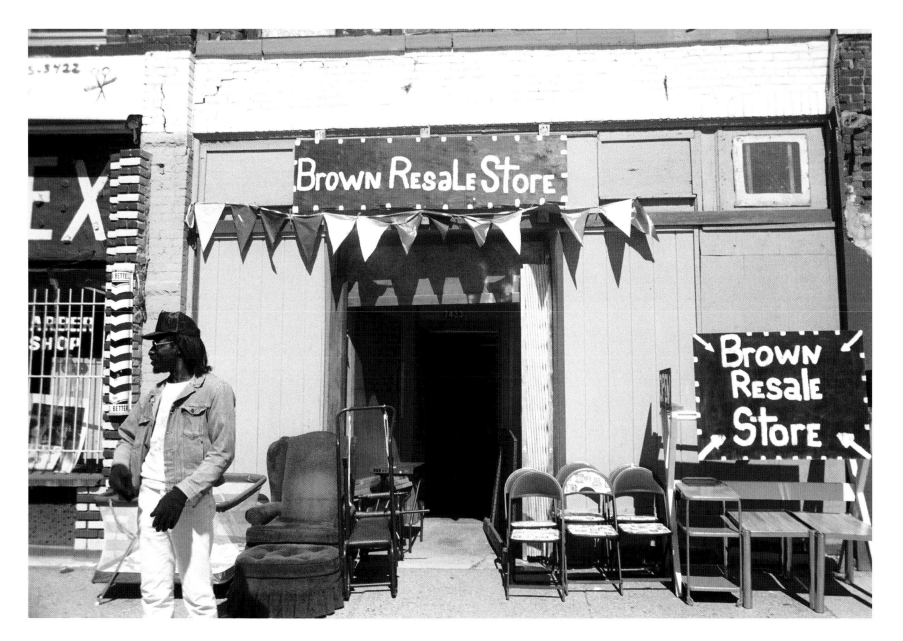

Brown Resale Store, 7433 Gratiot

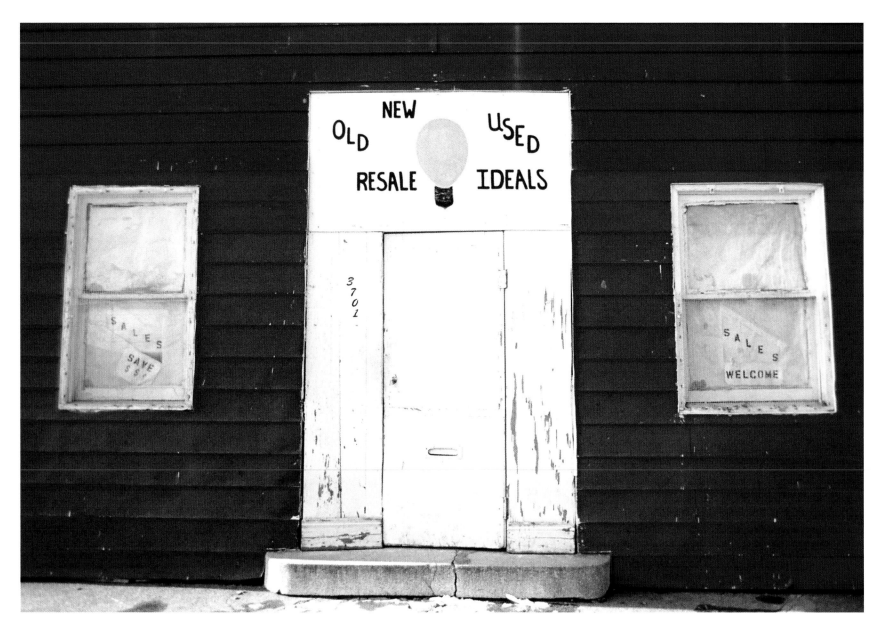

Resale Ideals, 3701 Concord near Mack

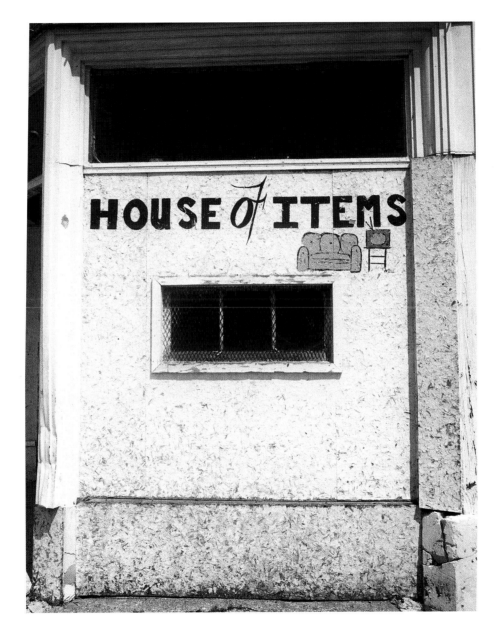

House of Items, Concord near Warren

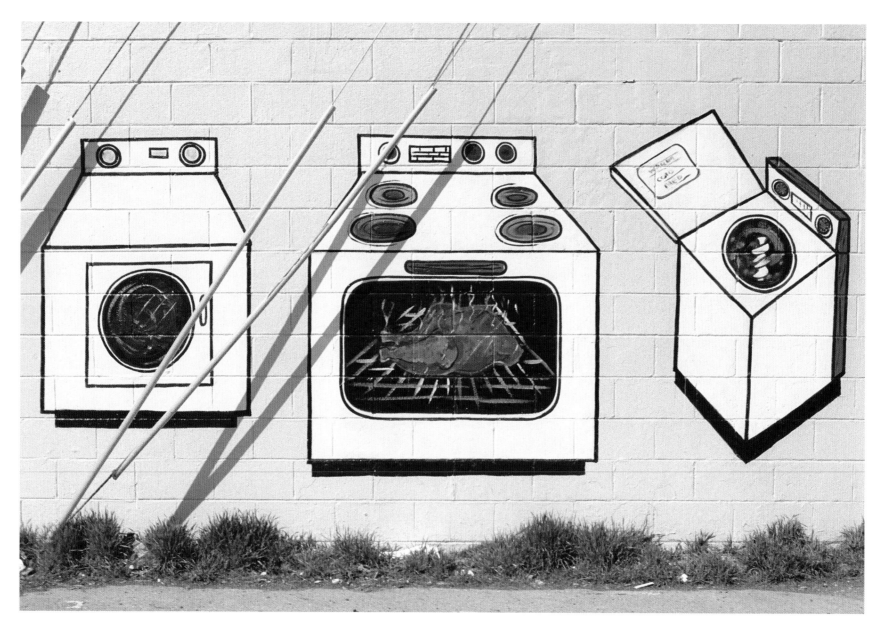

Appliances, 40 W. 8 Mile

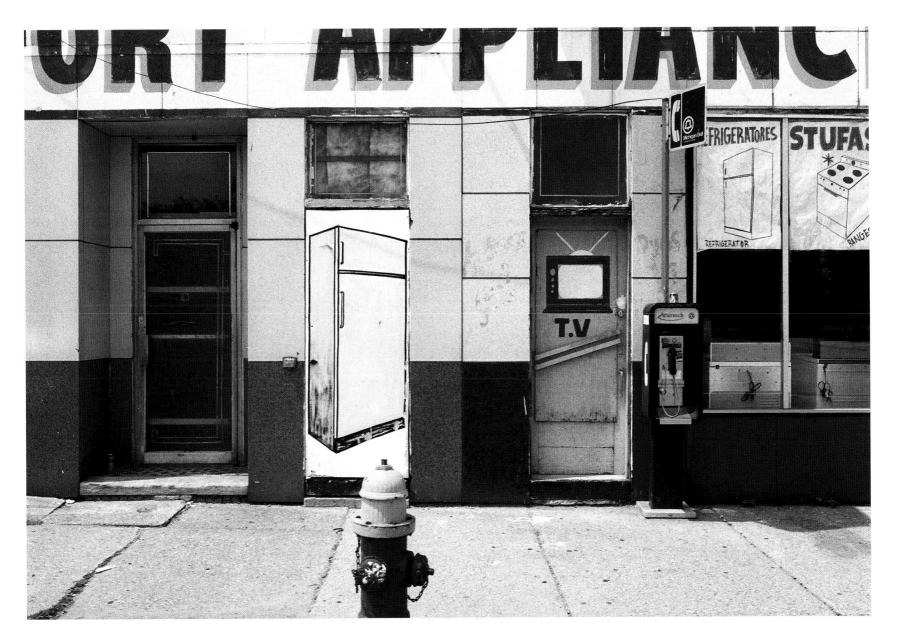

Fort Appliances, Fort St. west of Livernois

ENTERTAINMENT

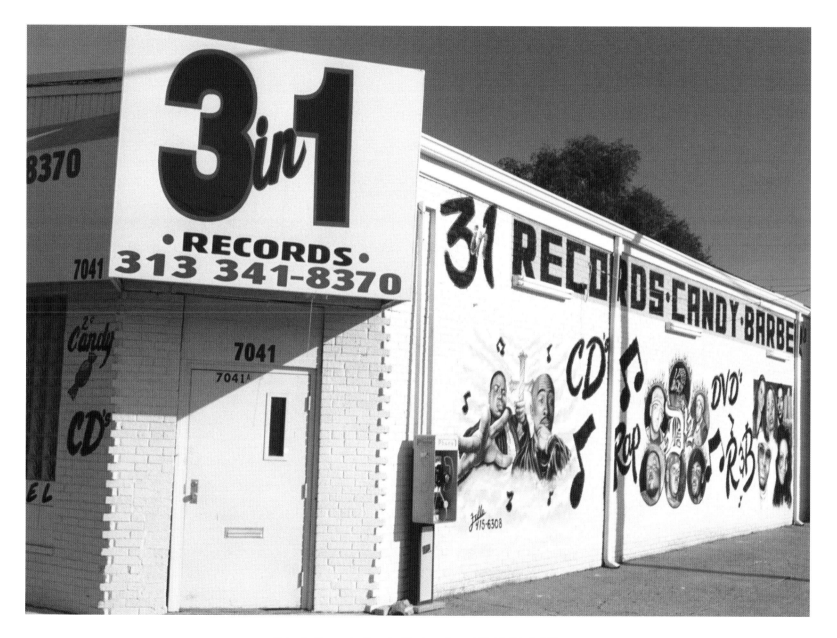

3 in 1 Records-Candy-Barbershop, 7041 W. 8 Mile

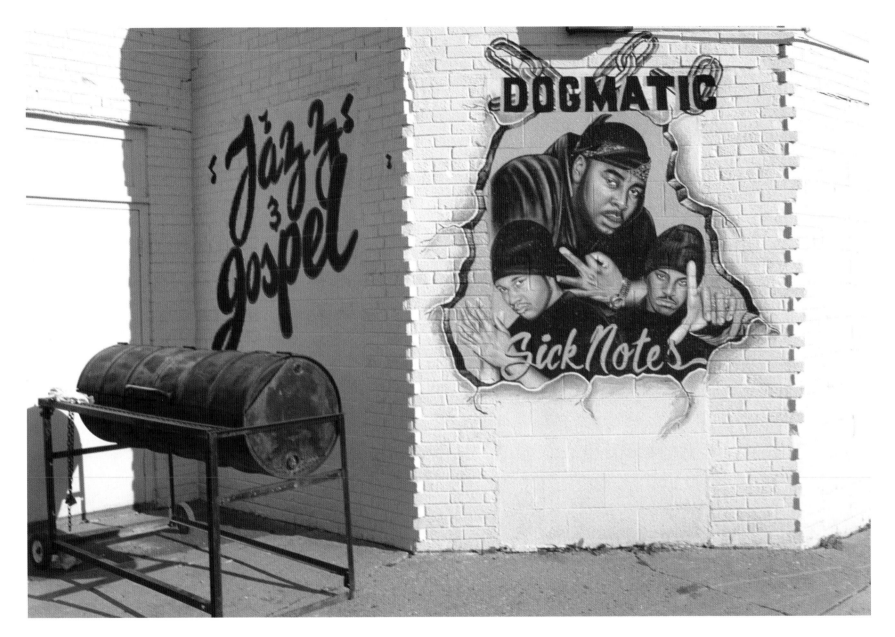

3 in 1 Records-Candy-Barbershop, 7041 W. 8 Mile

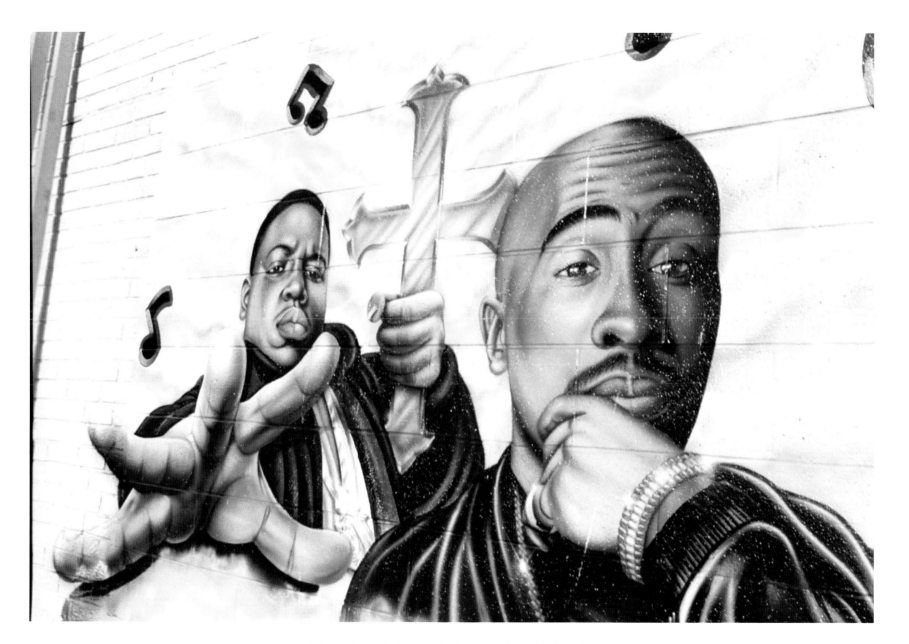

3 in 1 Records-Candy-Barbershop, 7041 W. 8 Mile

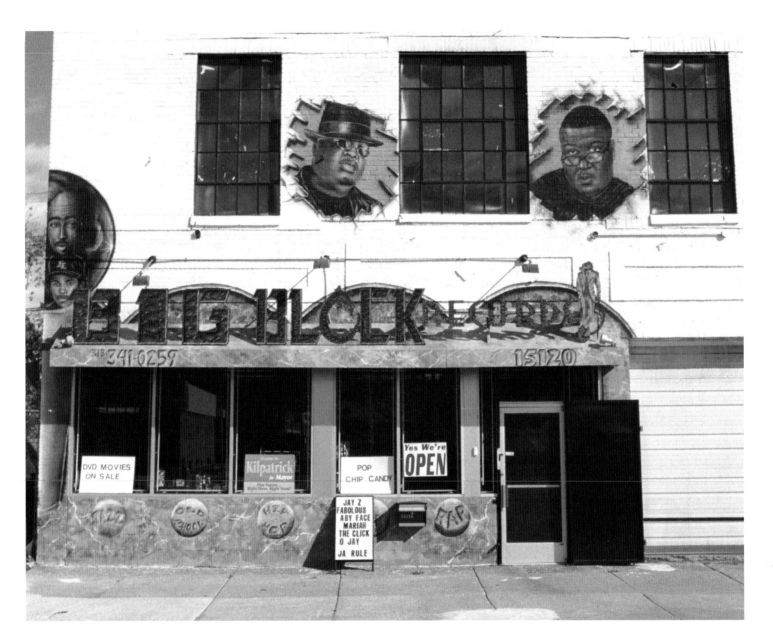

Big Block Records, 15120 Livernois

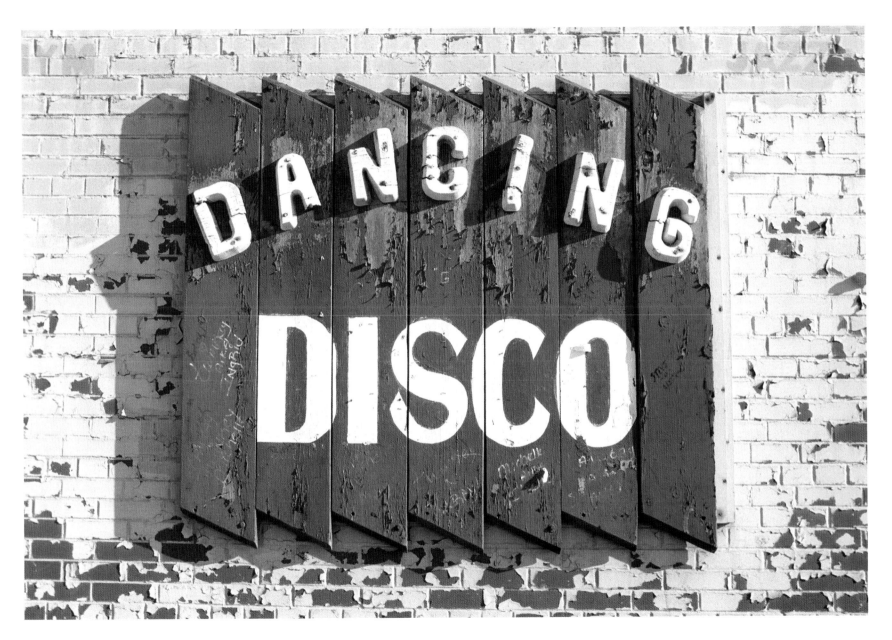

Dancing Disco, Van Dyke near McNichols

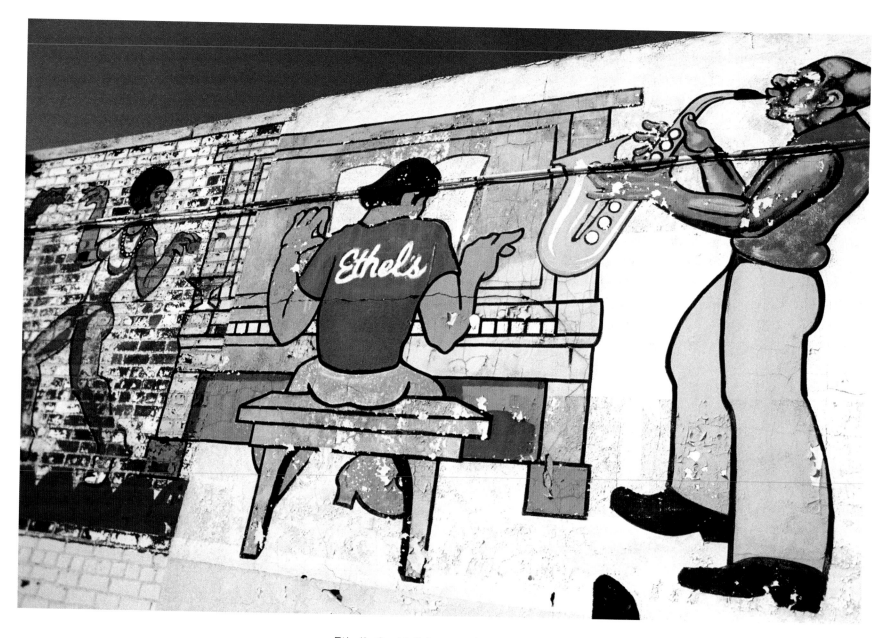

Ethel's Cocktail Lounge, 7341 Mack

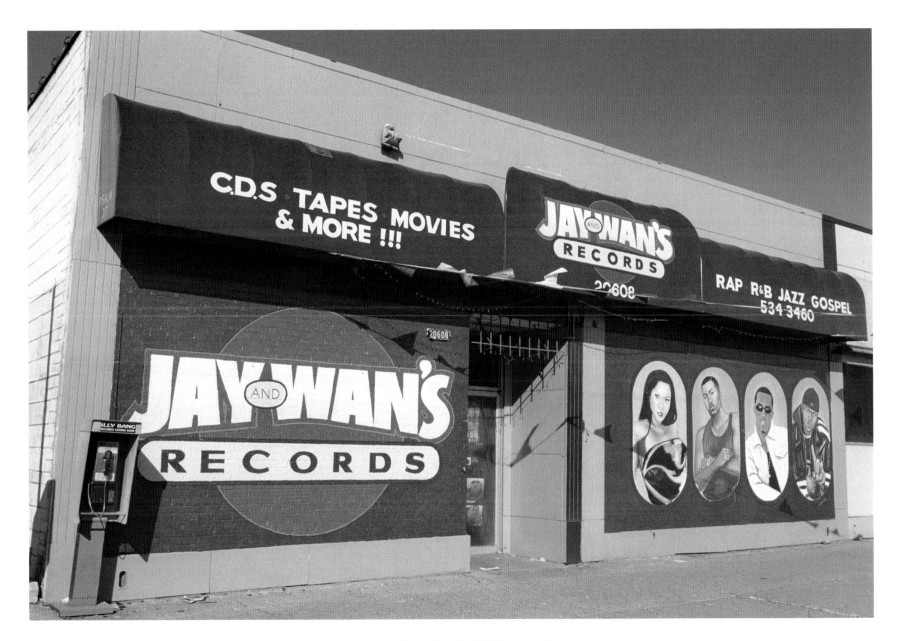

Jay and Wan's Records, W. 7 Mile near Wyoming

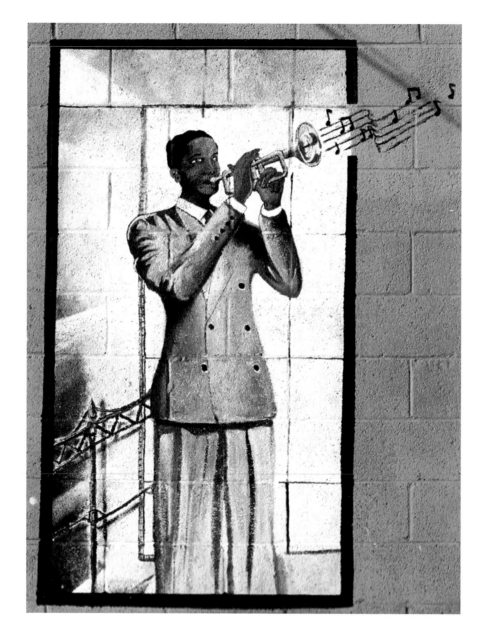

Paris 'N' Soul Food Restaurant, 10335 W. 8 Mile

9

SERVICES

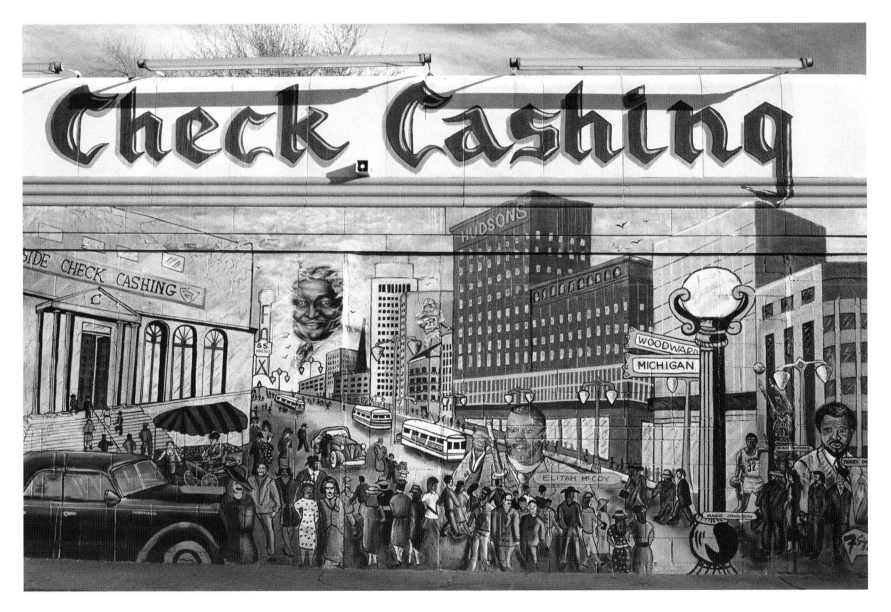

Eastside Check Cashing, 12240 E. McNichols

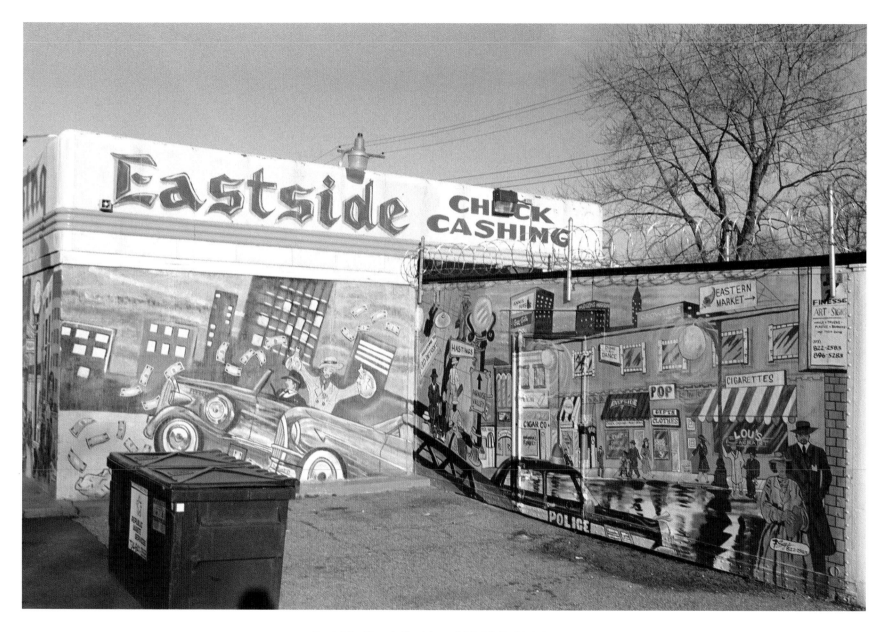

Eastside Check Cashing, 12240 E. McNichols

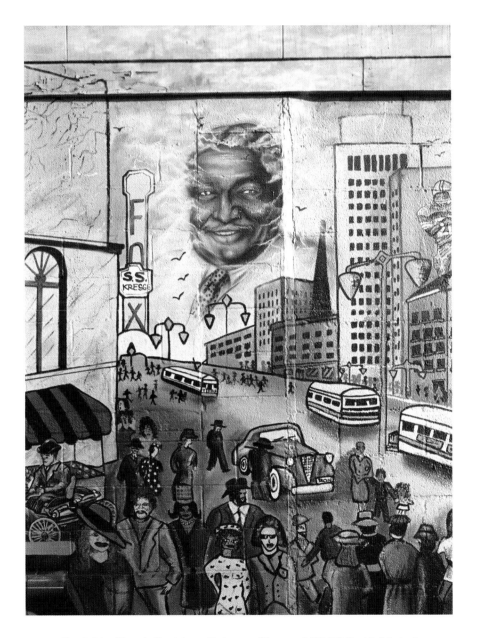

Eastside Check Cashing, Coleman Young, 12240 E. McNichols

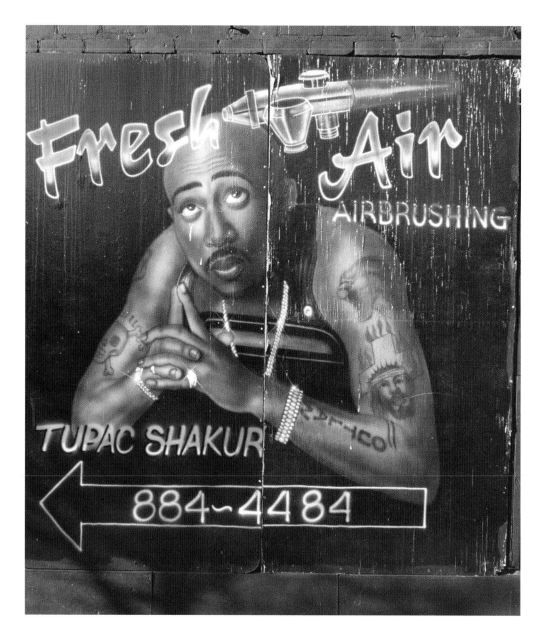

Fresh Air Airbrushing, E. Warren near Chalmers

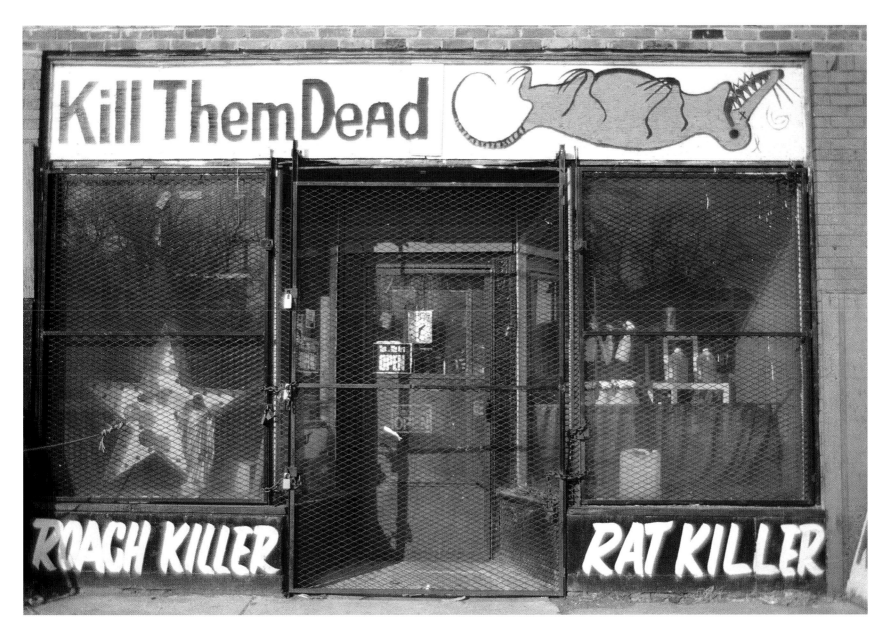

Kill Them Dead (Hudson Exterminating), 10631 E. Warren

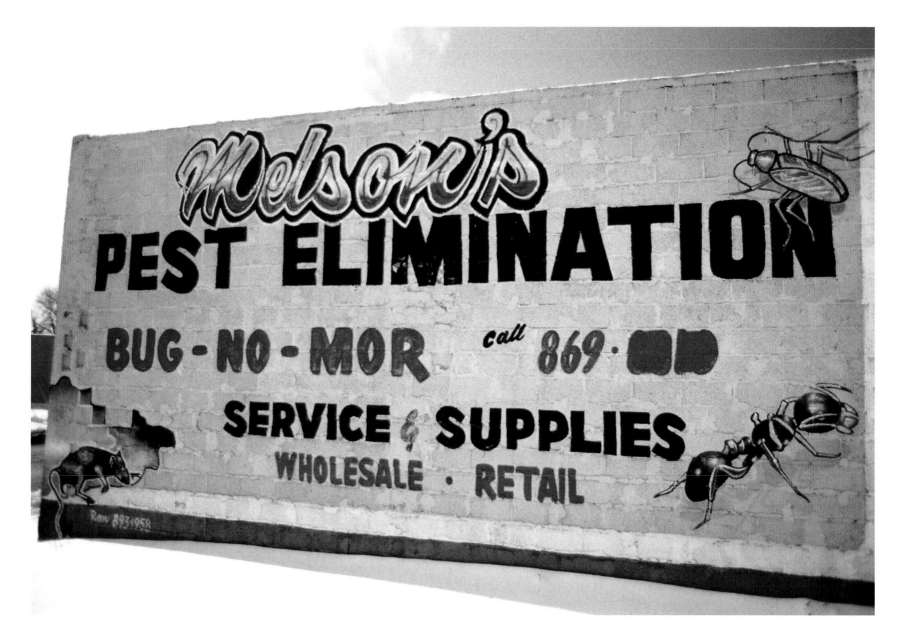

Melson's Pest Elimination, E. McNichols near Conant

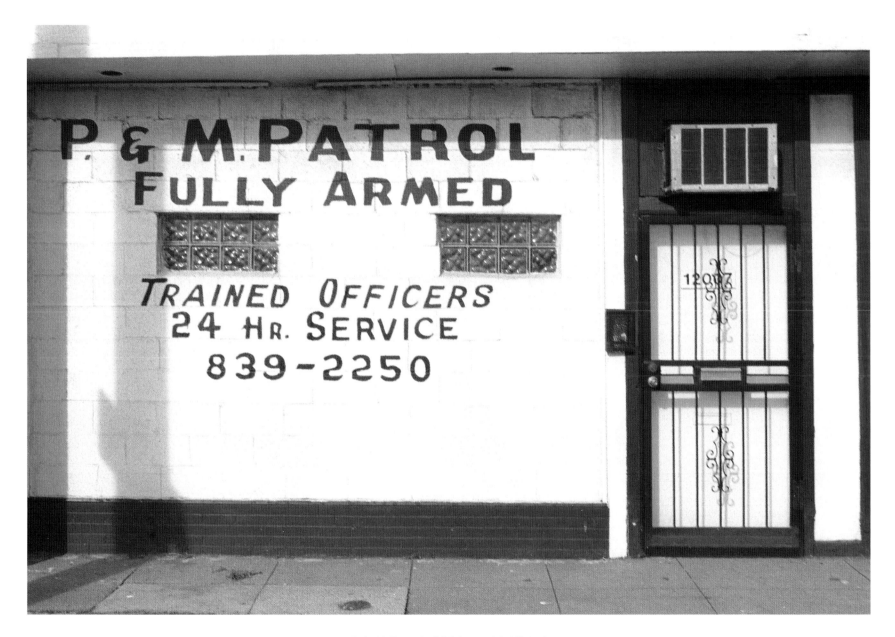

P & M Patrol, 12007 E. McNichols

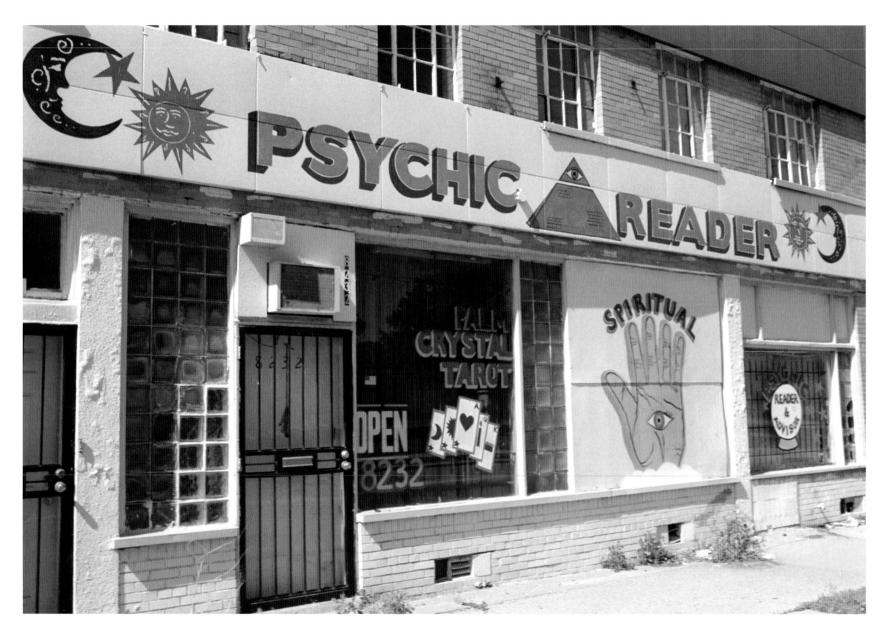

Psychic Reader, 8232 W. McNichols

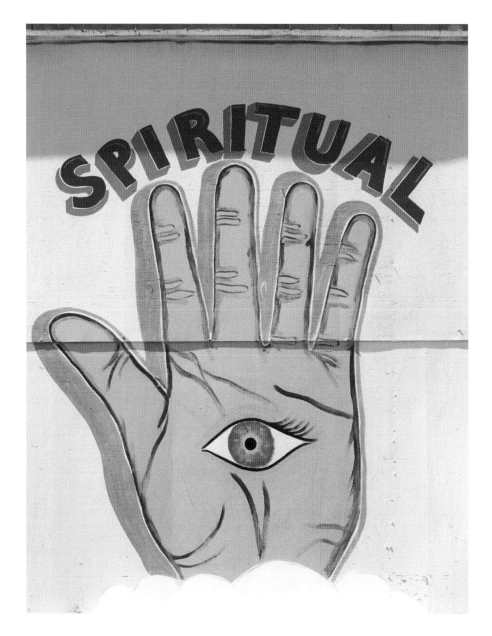

Psychic Reader, 8232 W. McNichols

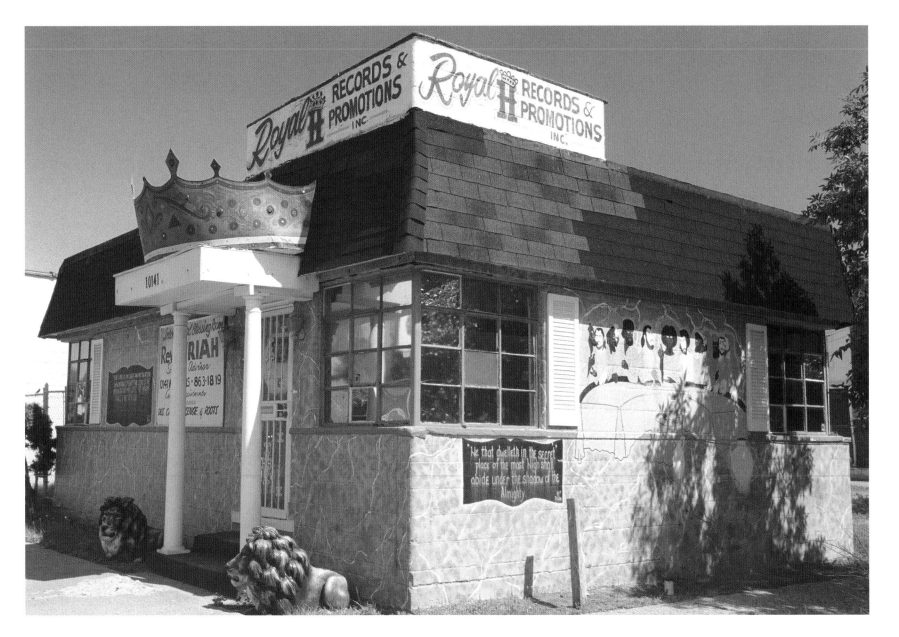

Royal H Records, 10141 W. McNichols

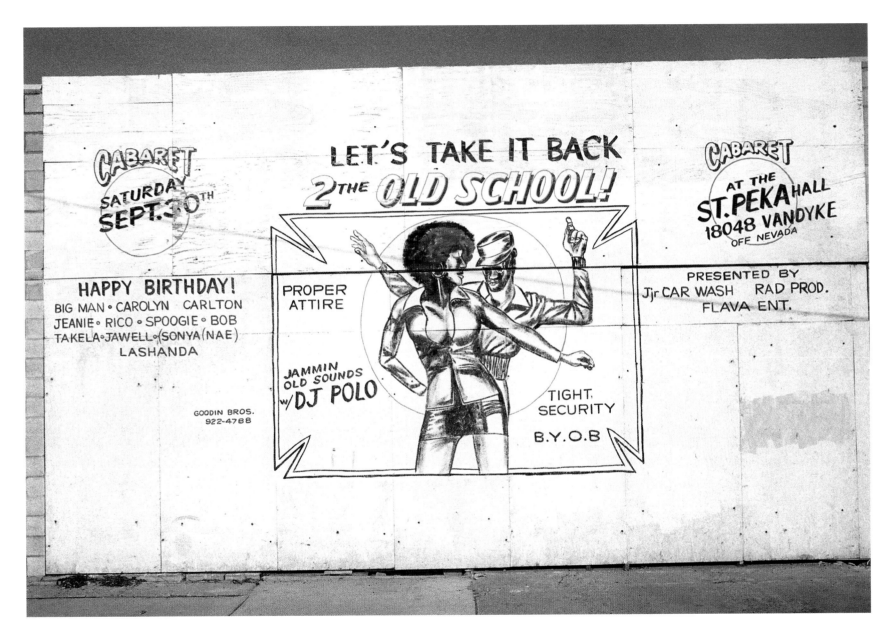

Old School, I-94 Service Drive west of Chalmers

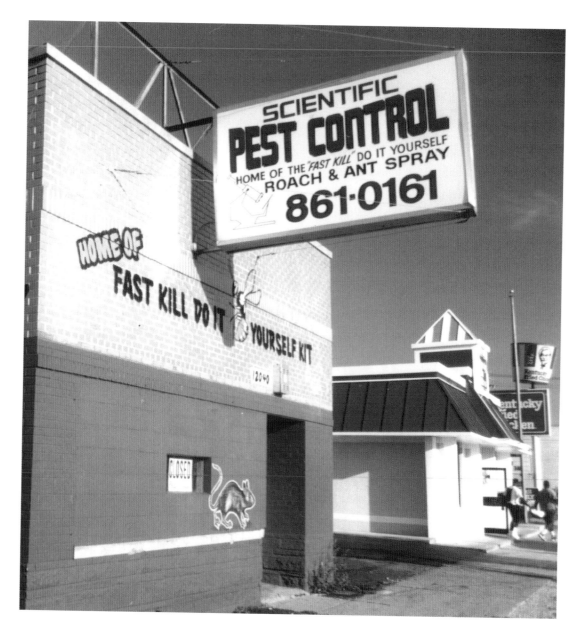

Scientific Pest Control, 12040 Greenfield

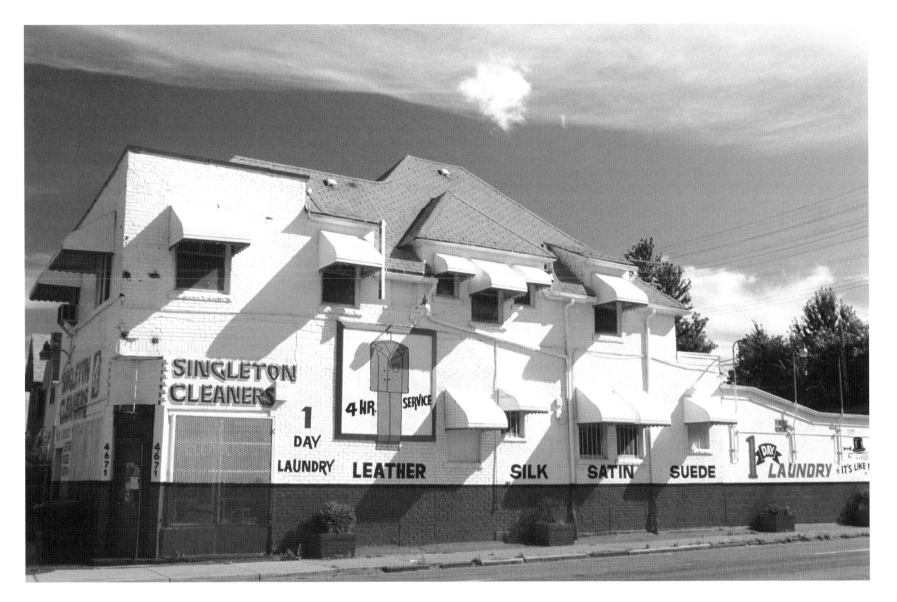

Singleton Cleaners, 9149 Forest

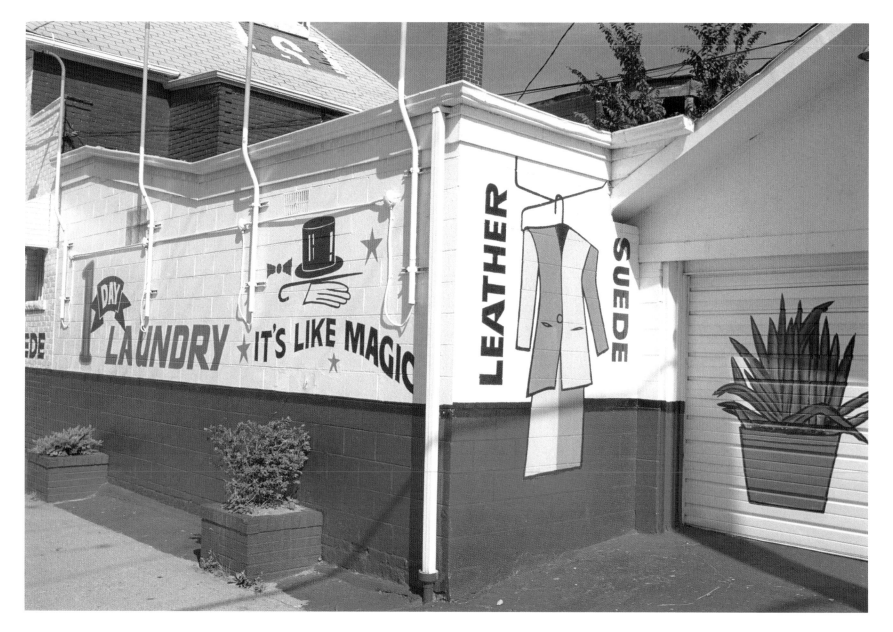

Singleton Cleaners, 9149 Forest

10

FOOD

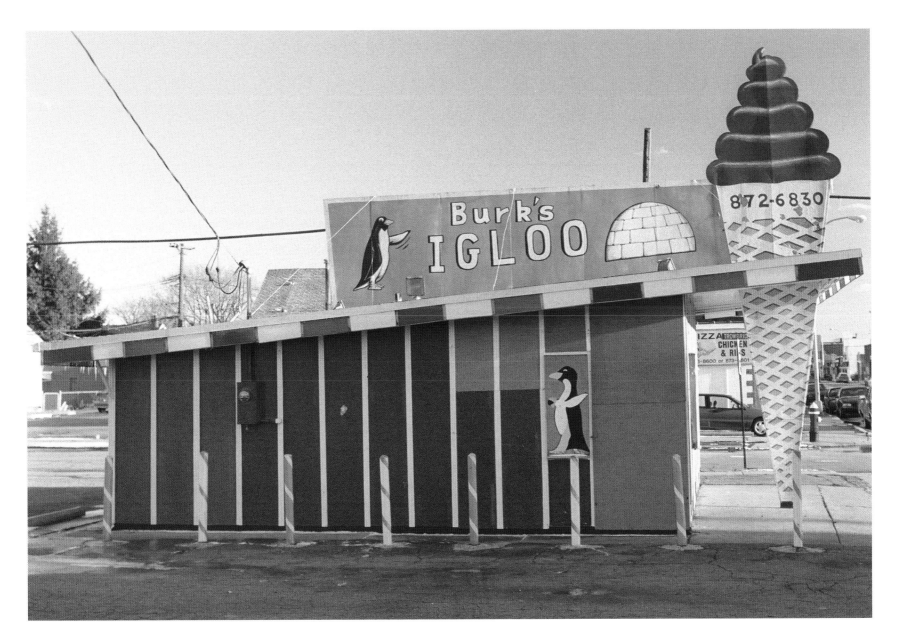

Burk's Igloo, 10300 Conant, Hamtramck

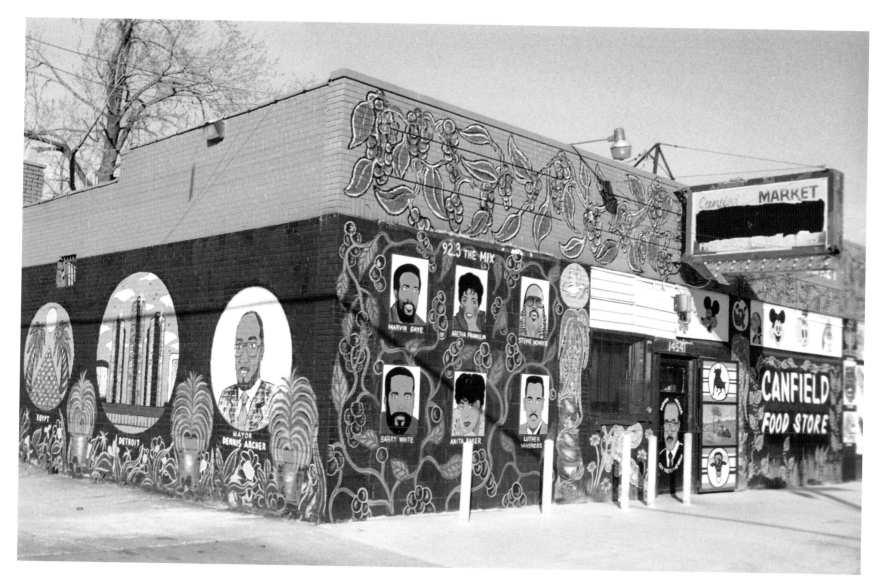

Canfield Market, 14541 St. Clair

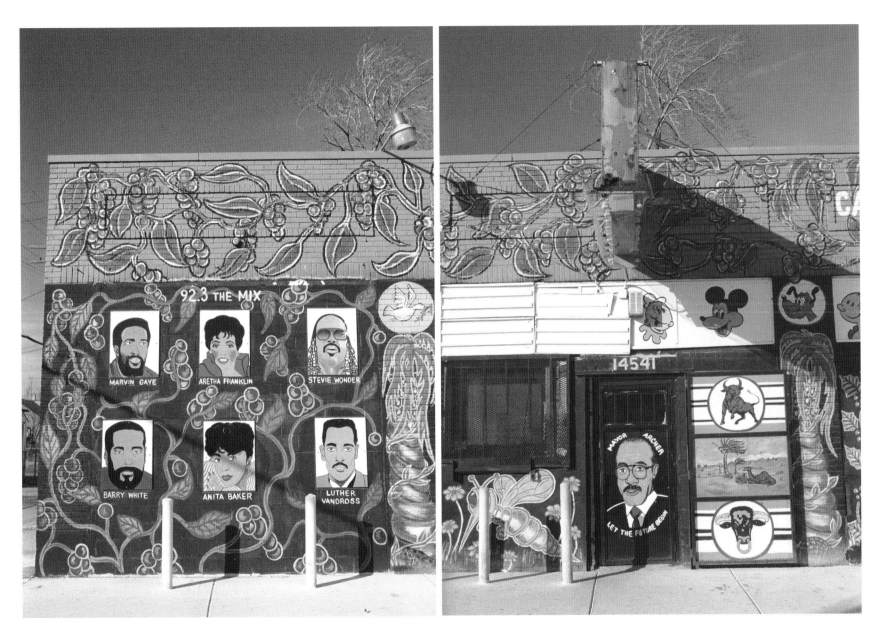

Canfield Market, 14541 St. Clair

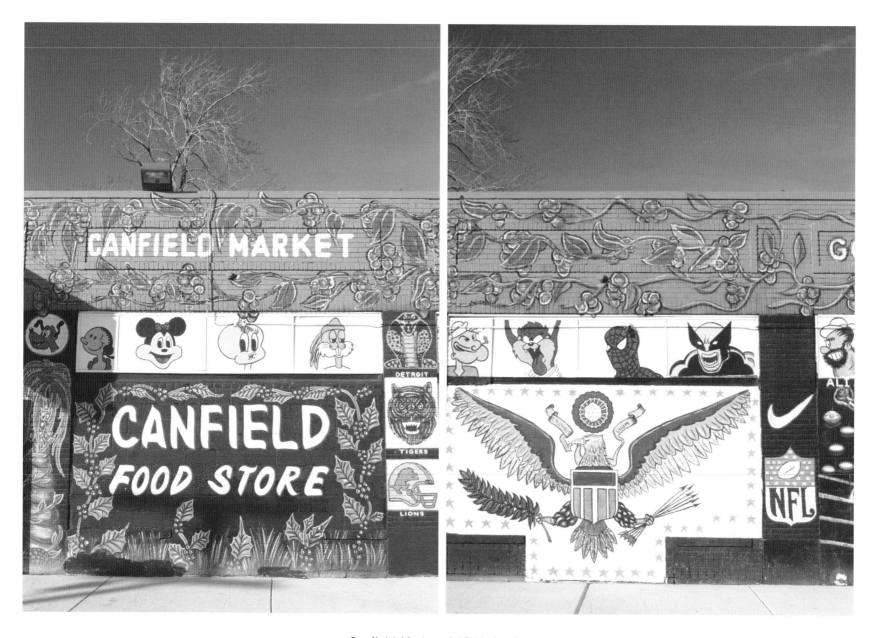

Canfield Market, 14541 St. Clair

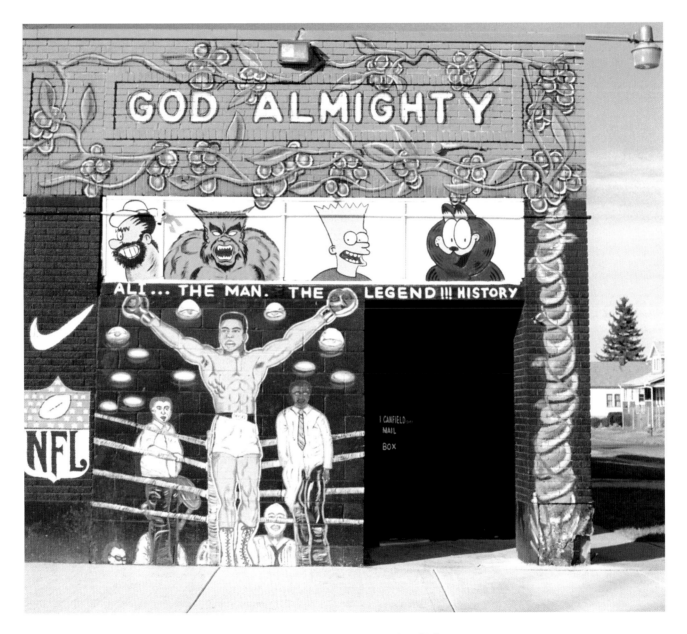

Canfield Market, 14541 St. Clair

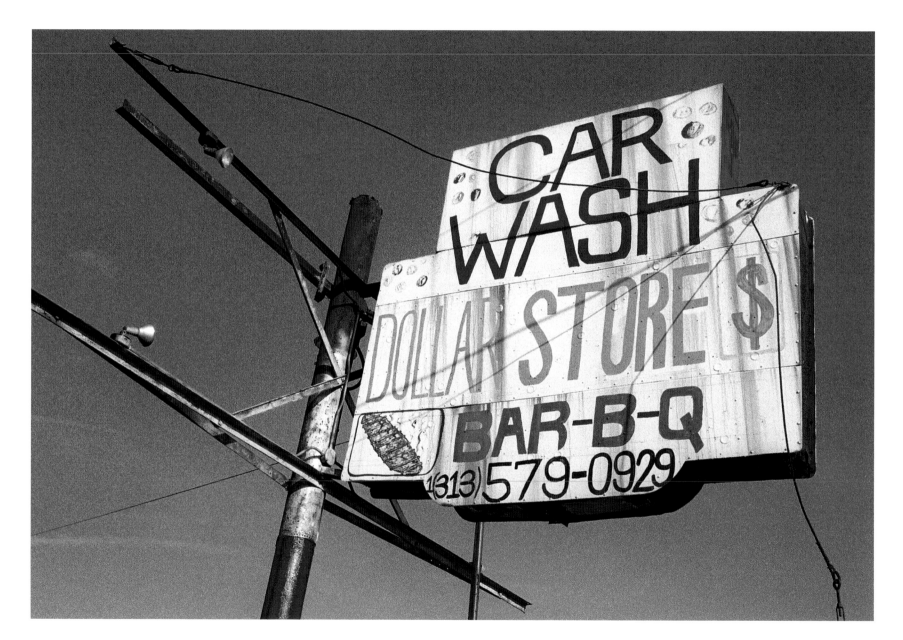

Car Wash, Dollar Store, Bar-B-Q, 8616 Harper

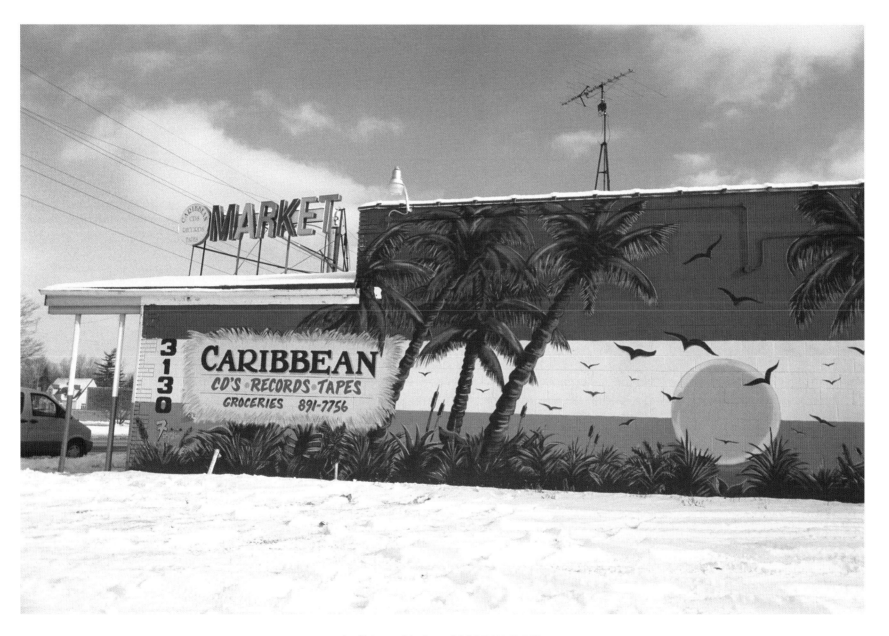

Caribbean Market, 18927 W. 7 Mile

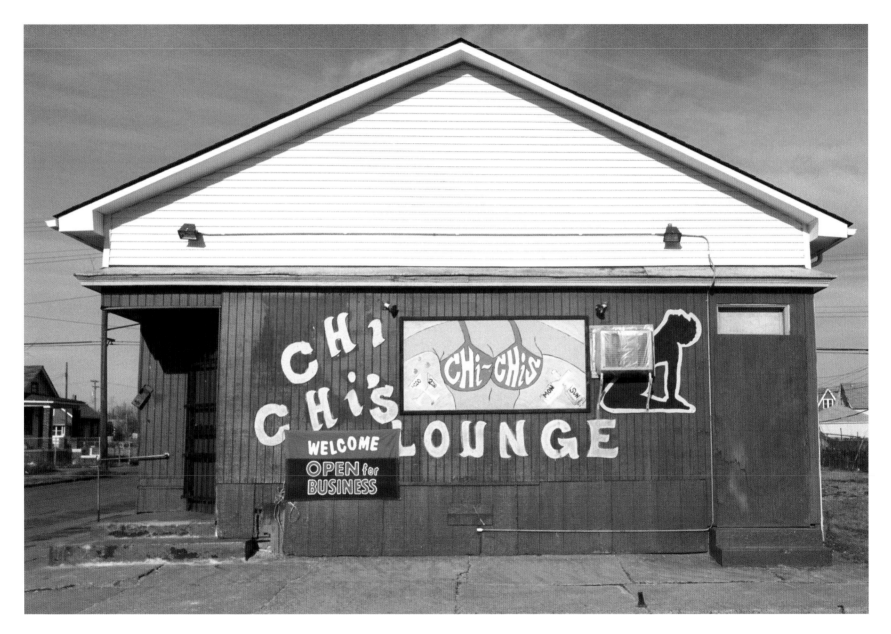

Chi Chi's Lounge, Harper at McClellan

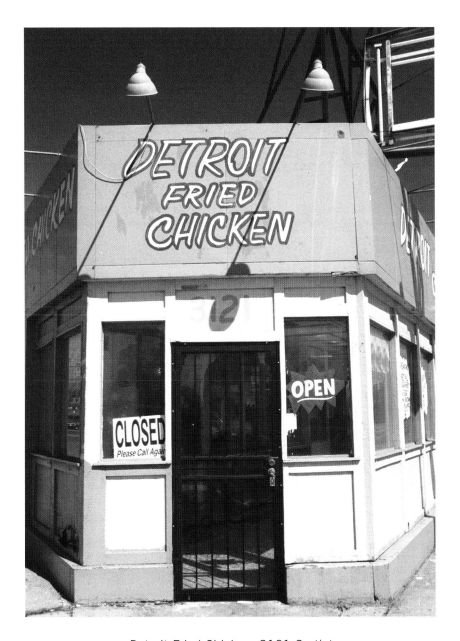

Detroit Fried Chicken, 3121 Gratiot

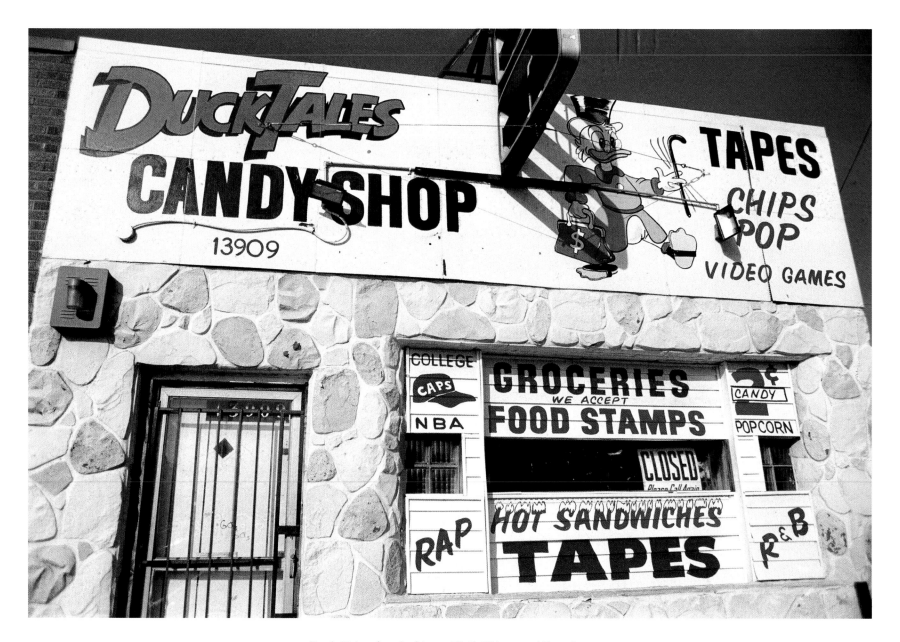

Duck Tales Candy Shop, W. 7 Mile near Wyoming

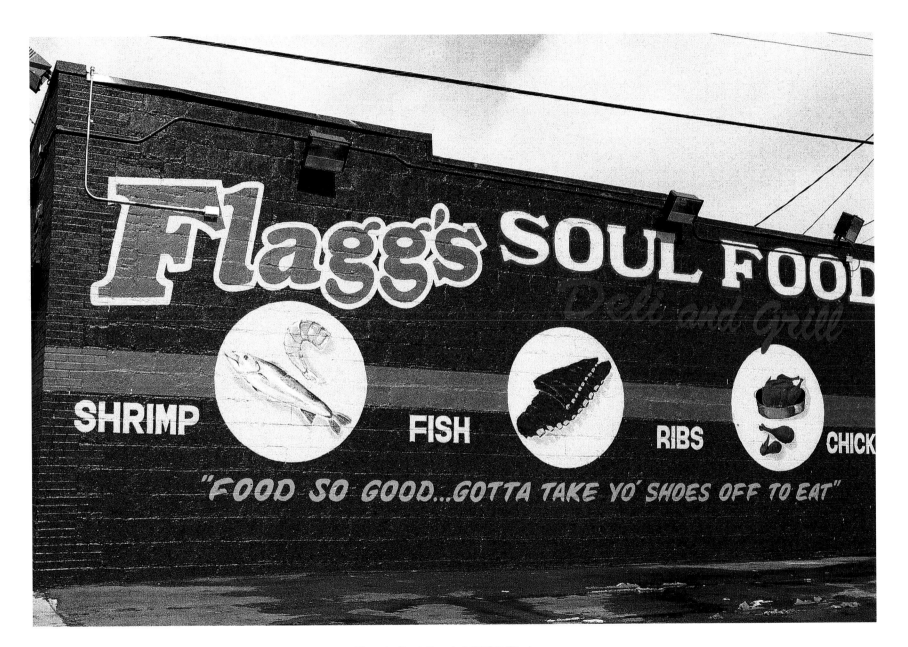

Flagg's Soul Food, 12330 Chalmers

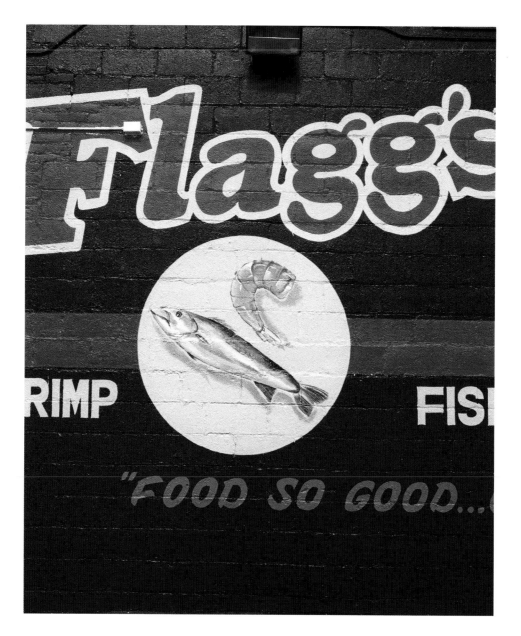

Flagg's Soul Food, 12330 Chalmers

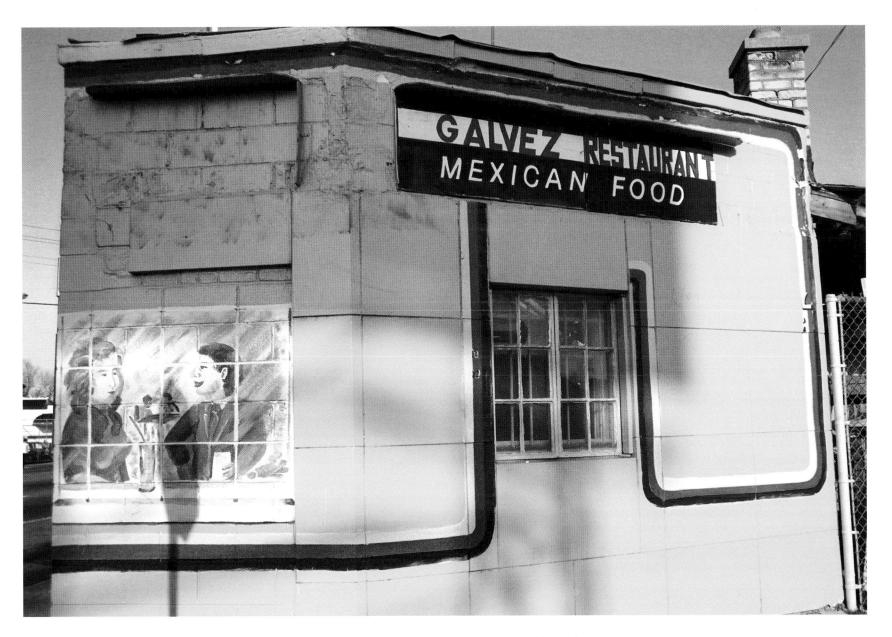

Galvez Restaurant, Michigan Ave. near Livernois

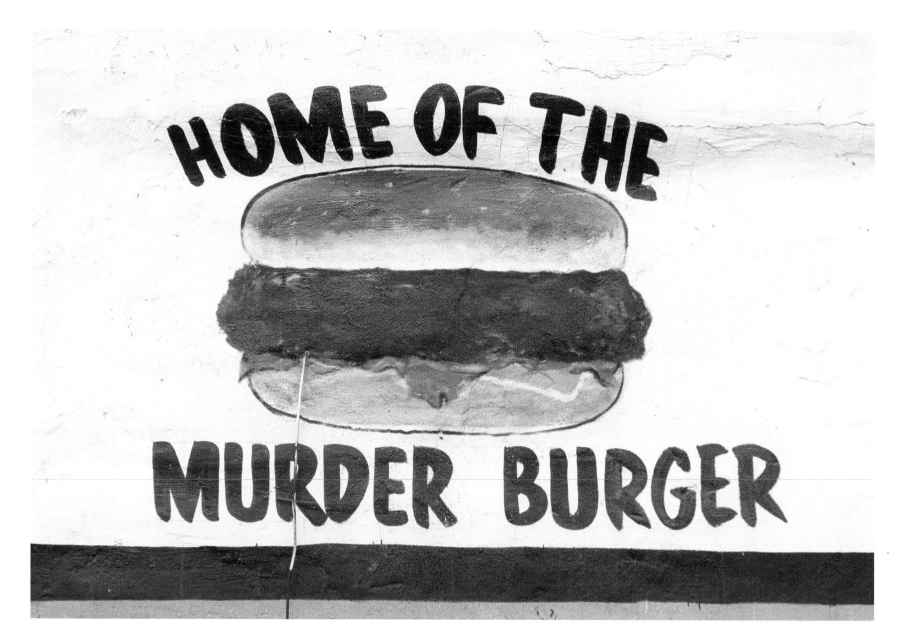

Home of the Murder Burger, 9838 Dexter

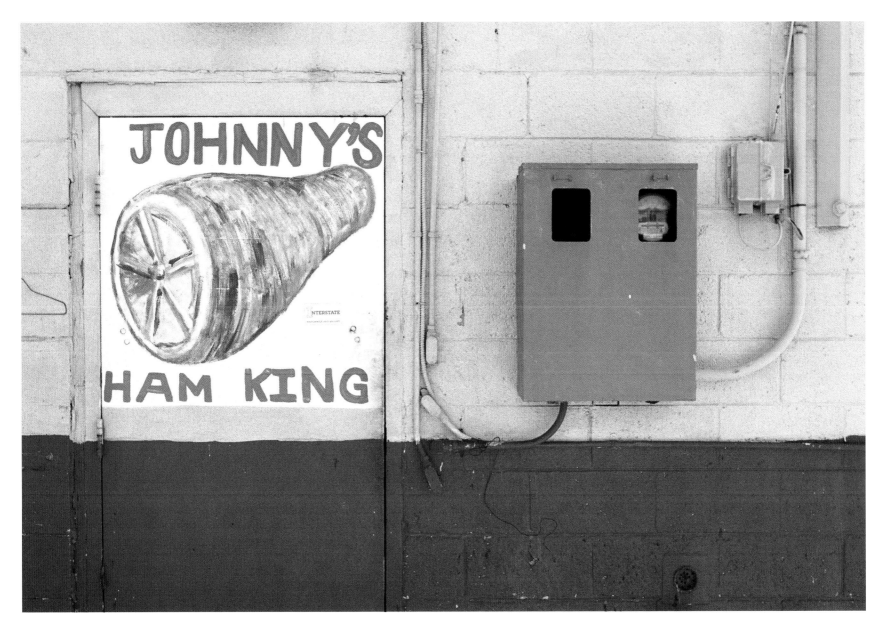

Johnny's Ham King, Fort St. at 14th St.

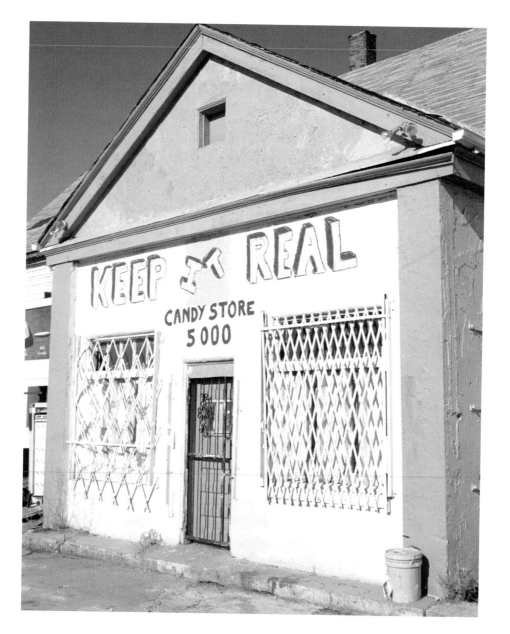

Keep It Real Candy Store, 5000 E. Forest

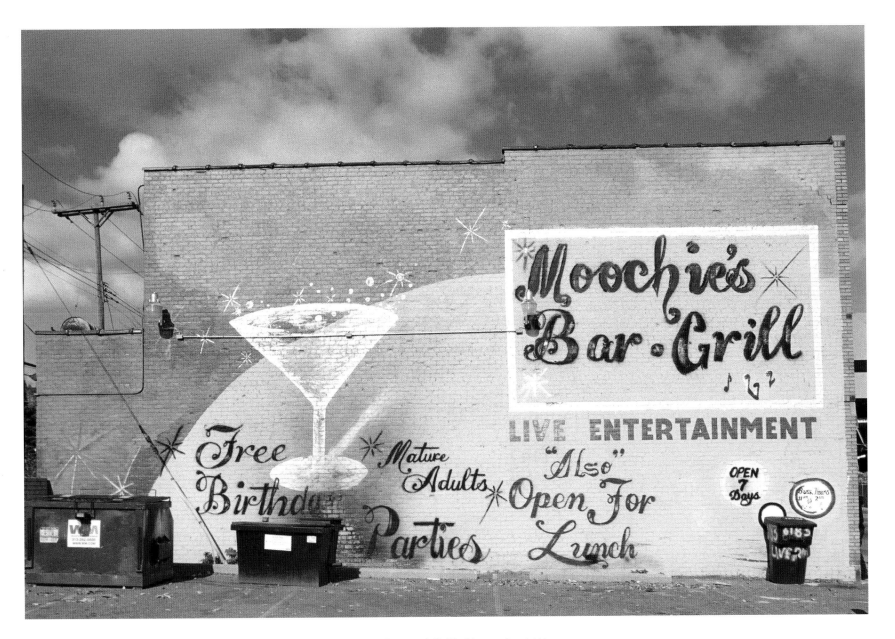

Moochie's Bar and Grill, Livernois at Warren

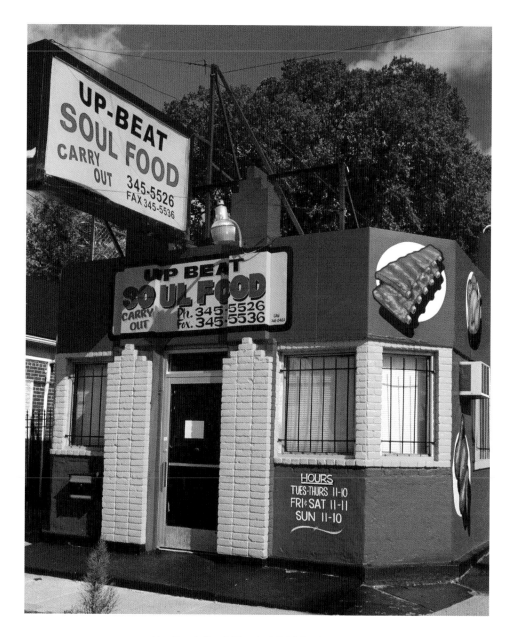

Up-Beat Soul Food, 17310 Livernois

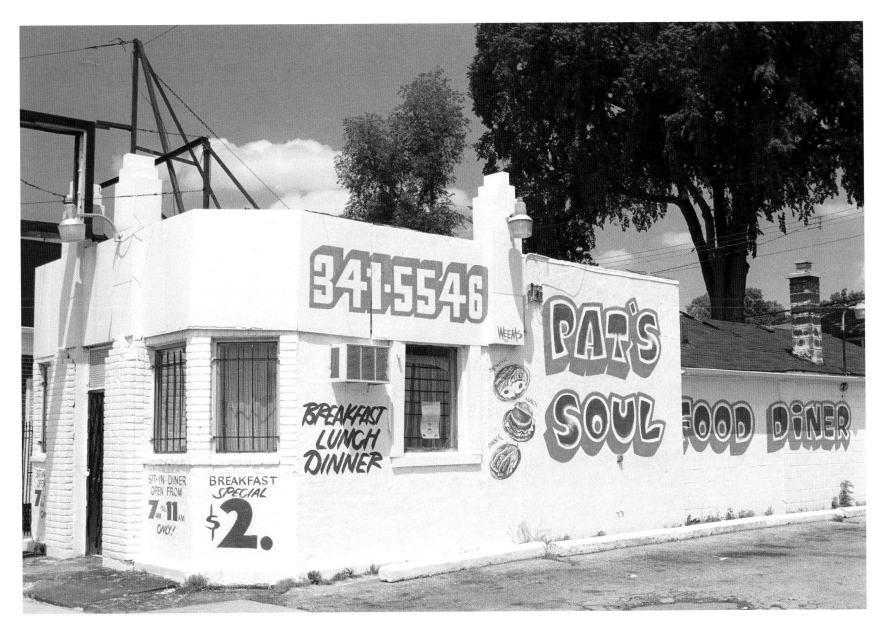

Pat's Soul Food Diner, 17310 Livernois

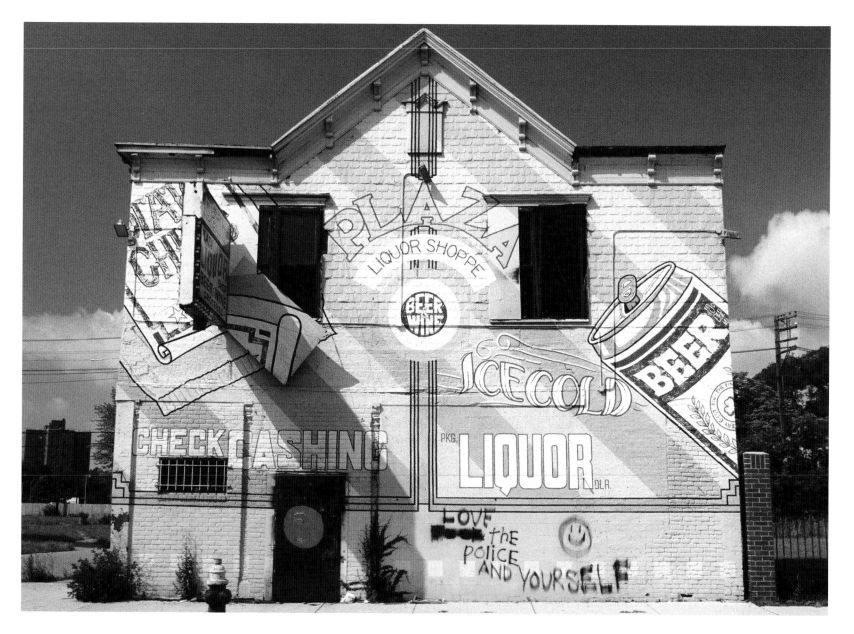

Plaza Liquor Shoppe, 4001 Third Ave.

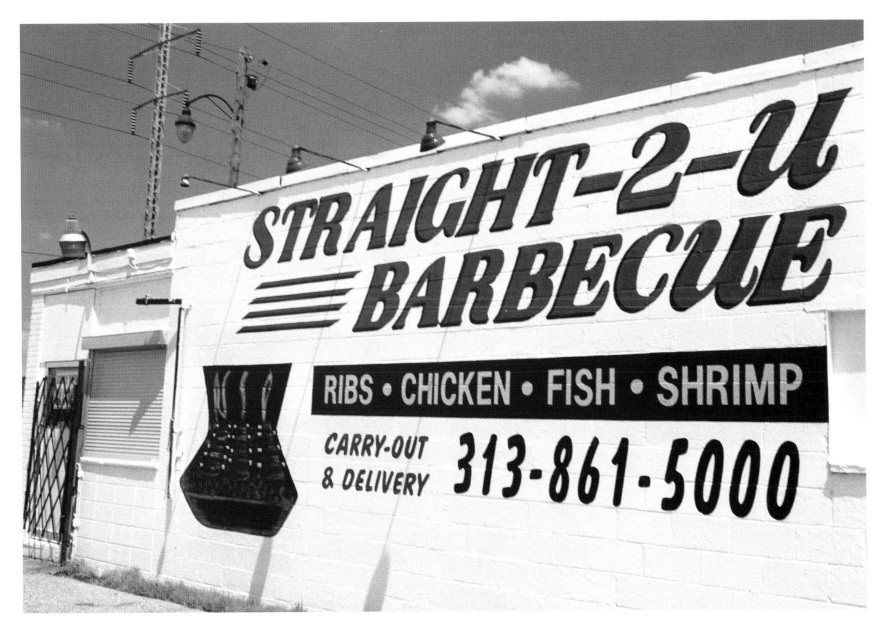

Straight-2-U Barbecue, 10100 W. 8 Mile

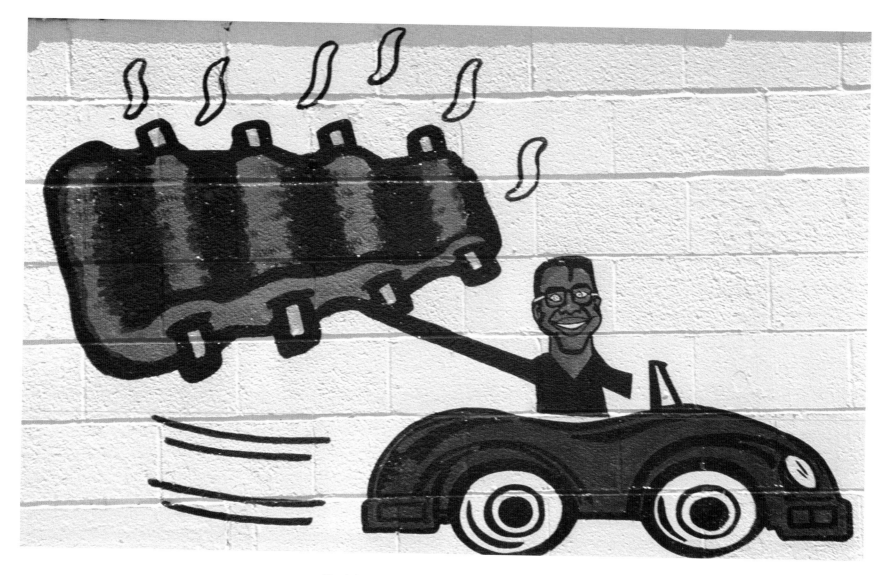

Straight-2-U Barbecue, 10100 W. 8 Mile

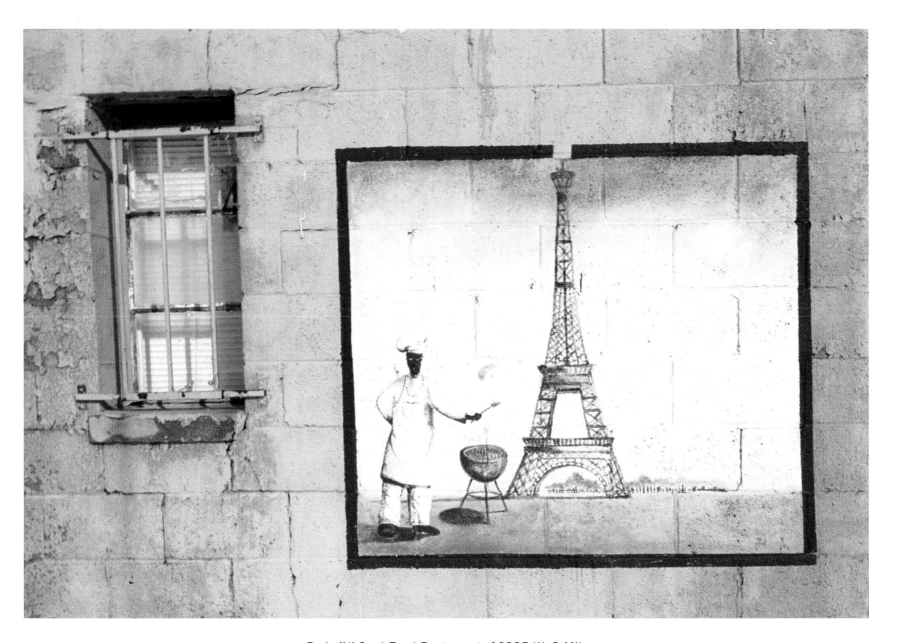

Paris 'N' Soul Food Restaurant, 10335 W. 8 Mile

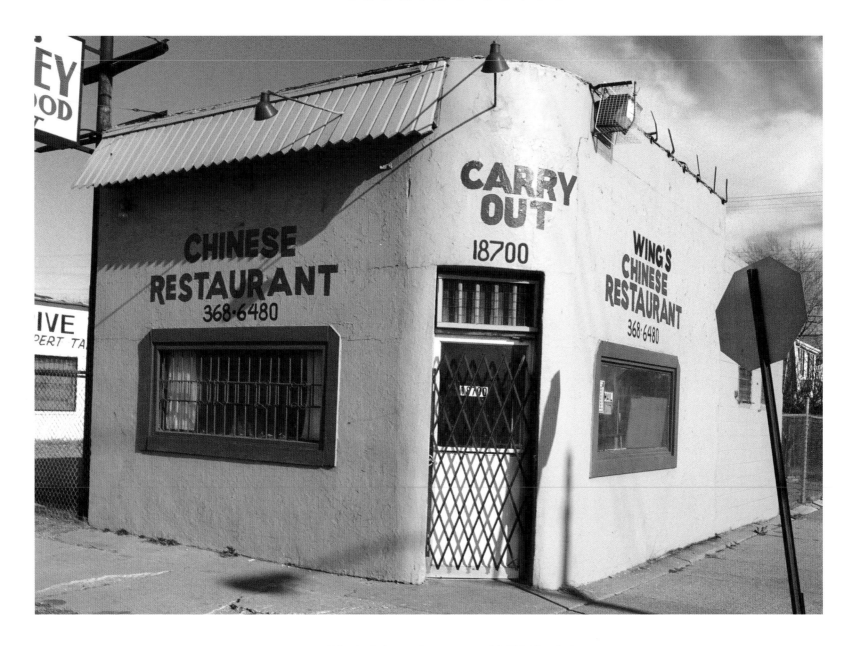

Wing's Chinese Restaurant, 18700 Van Dyke

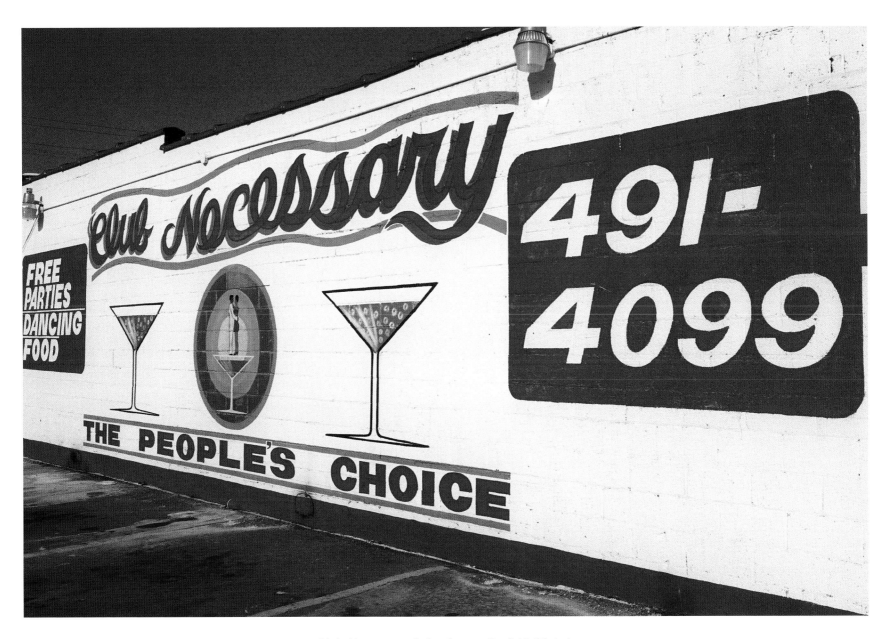

Club Necessary, Schaefer south of McNichols

11

HAIR

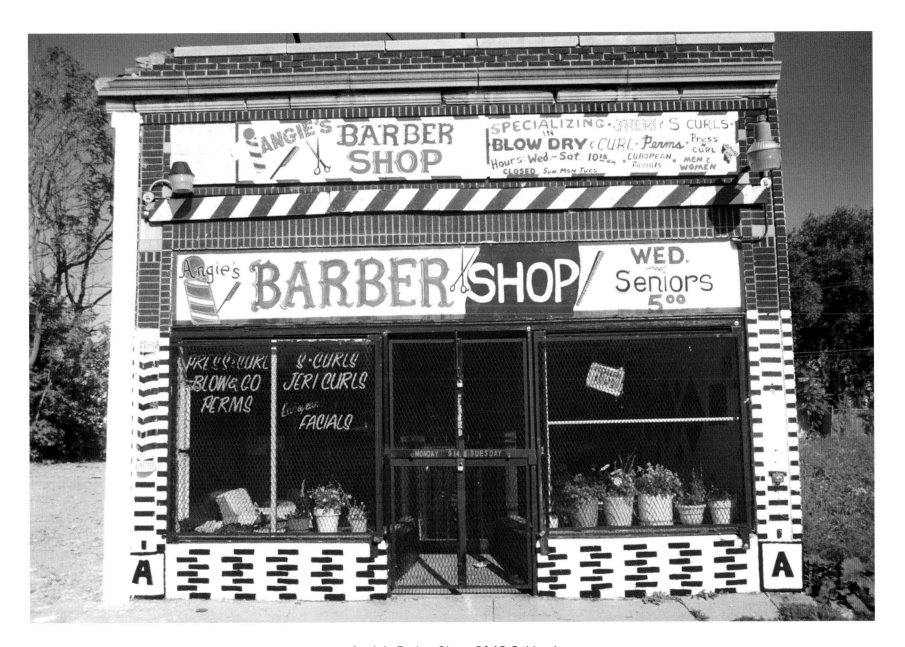

Angie's Barber Shop, 9148 Oakland

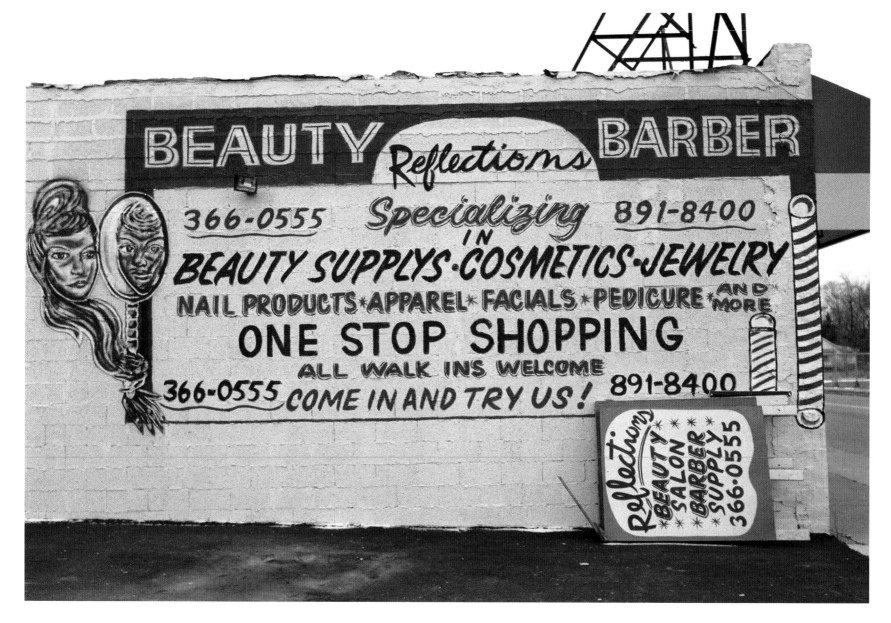

Beauty Reflections Salon, W. 8 Mile near Meyers

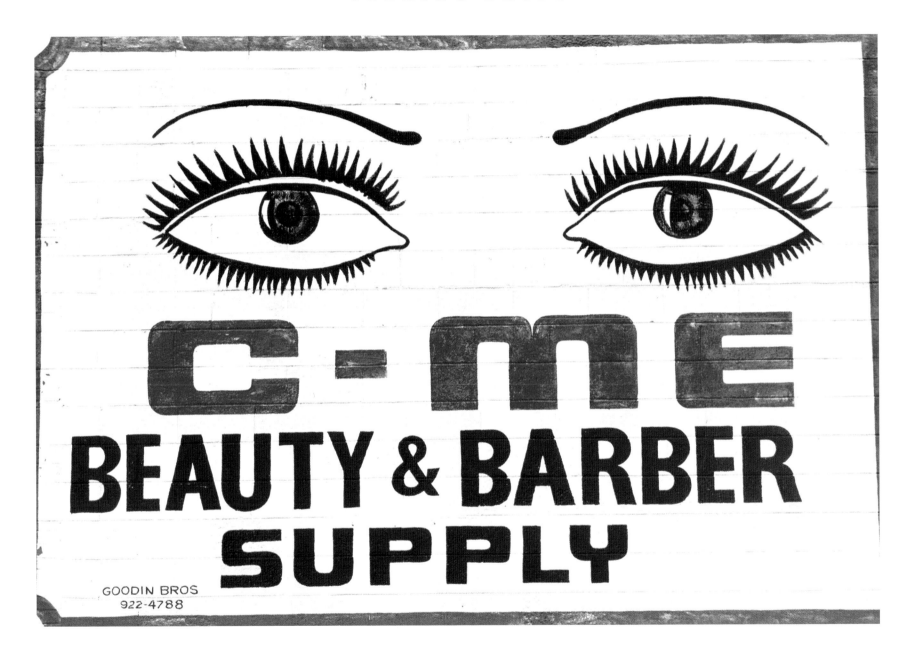

C-Me Beauty and Barber Supply, 11054 Gratiot

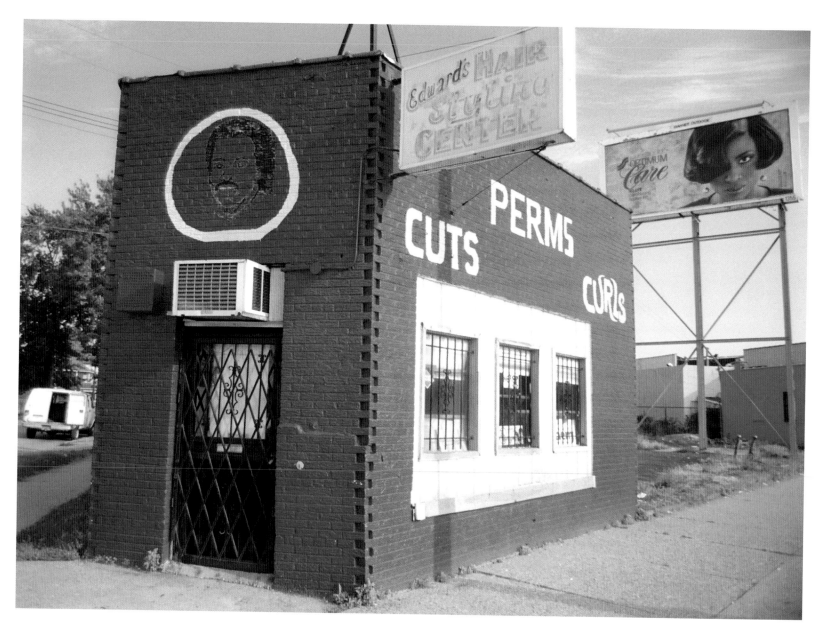

Edward's Hair Styling Center, 6678 Gratiot

Golden Touch Beauty Salon, 13711 E. 7 Mile

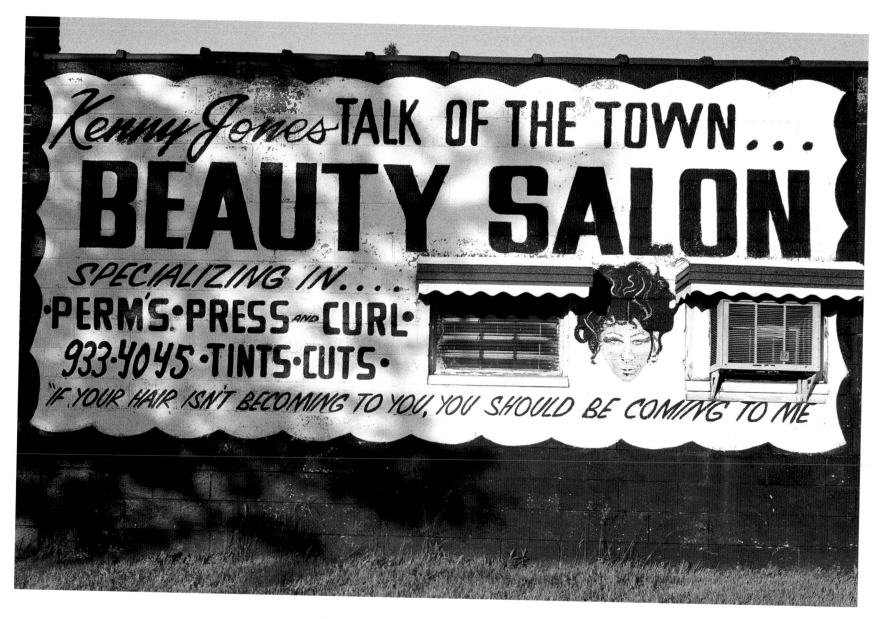

Kenny Jones Beauty Salon, 13001 Joy

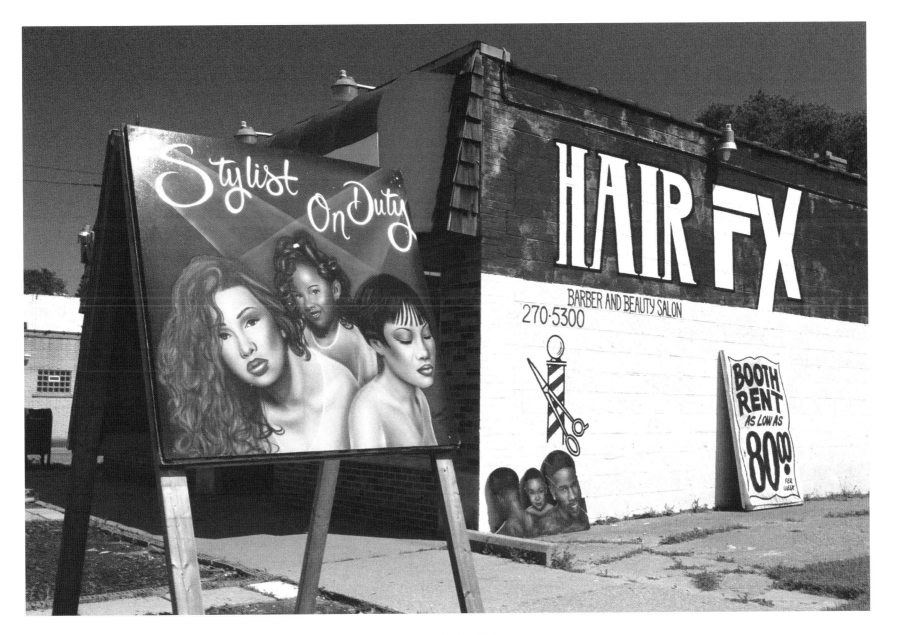

Hair FX, 13327 W. McNichols

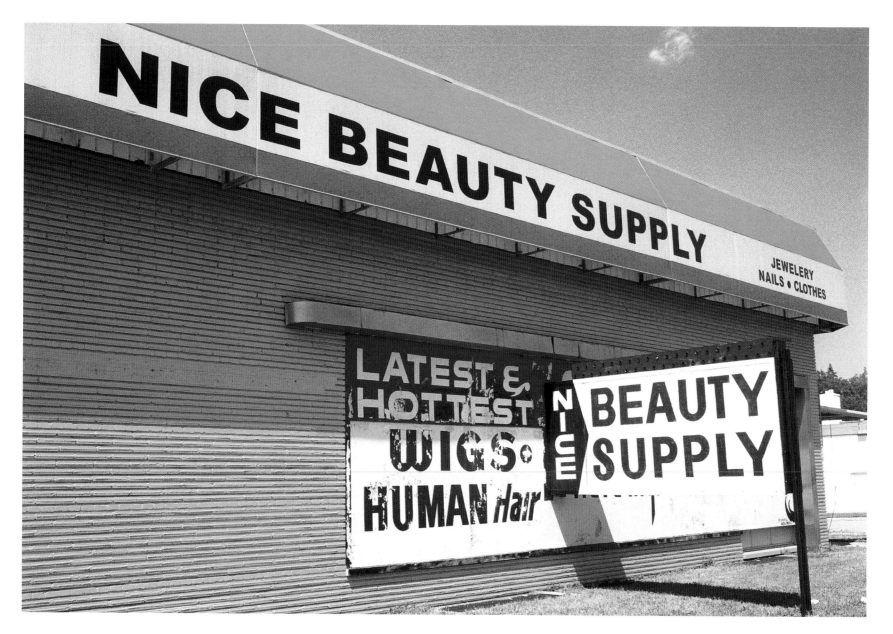

Nice Beauty Supply, 18820 W. McNichols

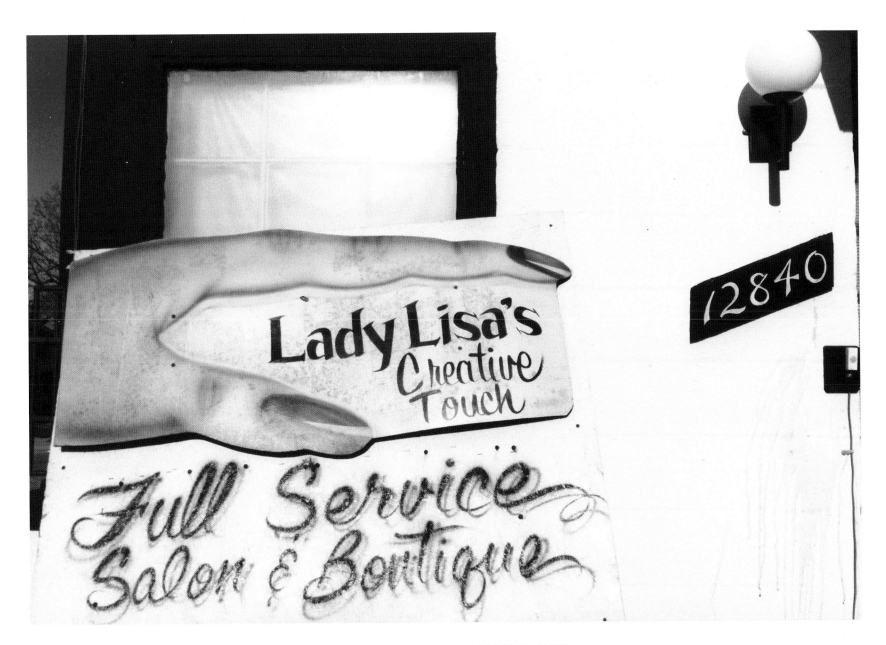

Lady Lisa's Creative Touch, 12840 W. 7 Mile

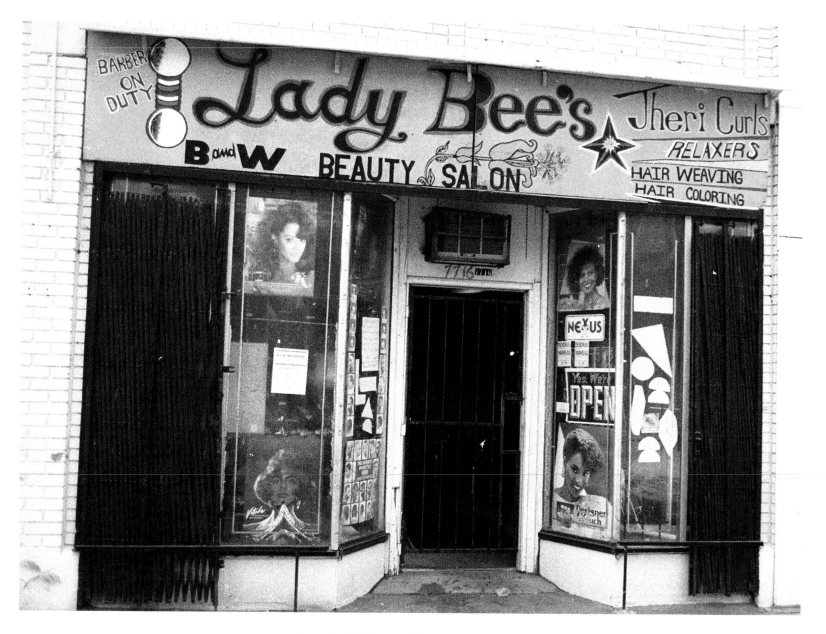

Lady Bee's Beauty Salon, 7716 Harper

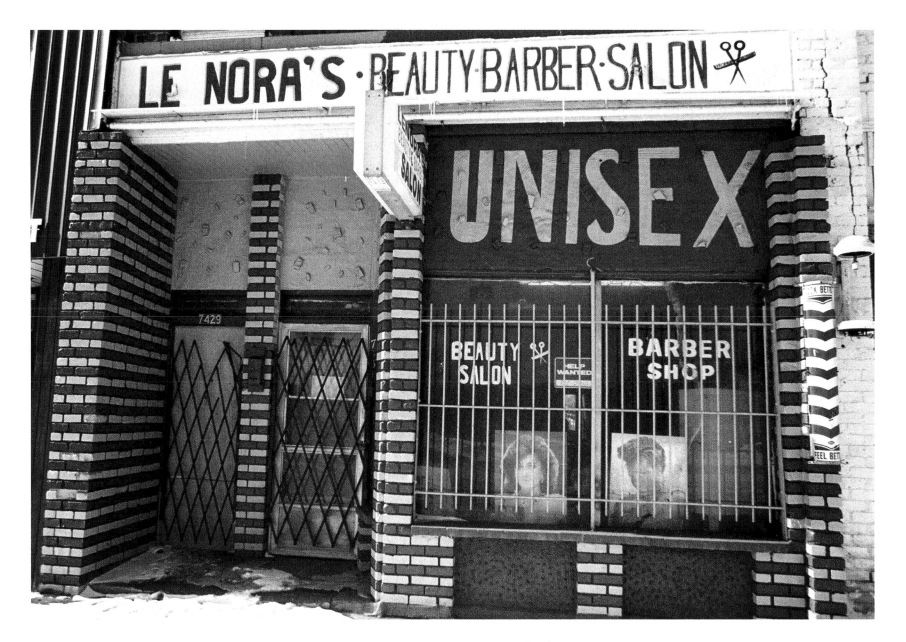

Le Nora's Beauty Barber Salon, 7431 Gratiot

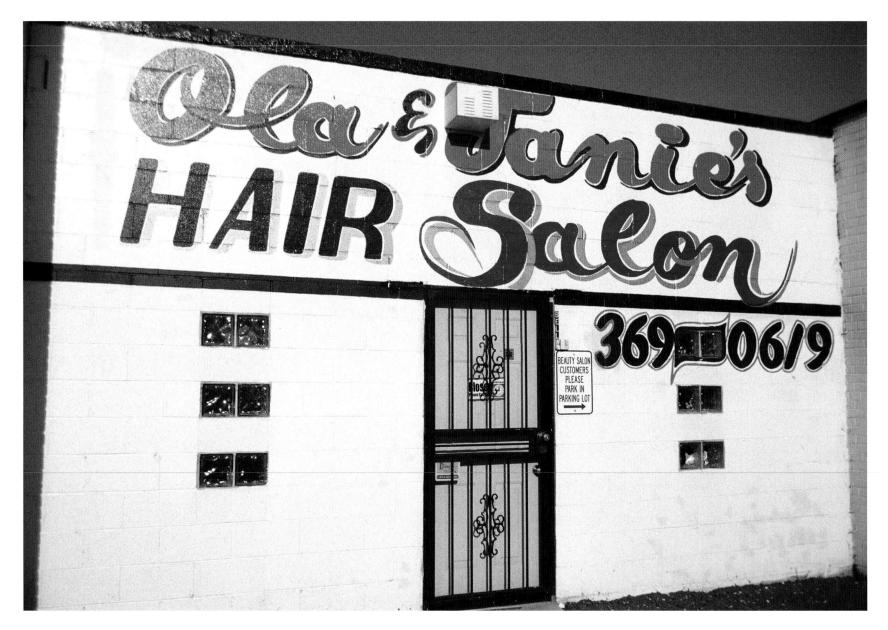

Ola & Janie's Hair Salon, Livernois near Oakman Blvd.

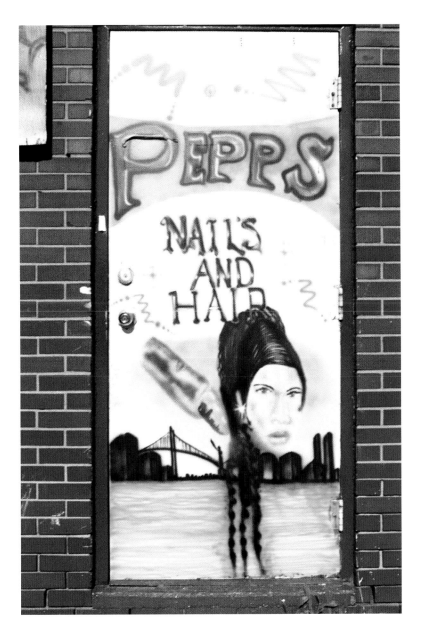

Pepps Nails and Hair, Livernois north of Grand River

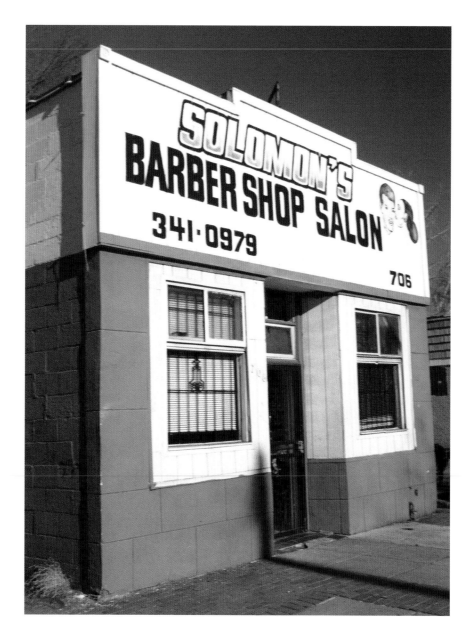

Solomon's Barber Shop Salon, location unknown

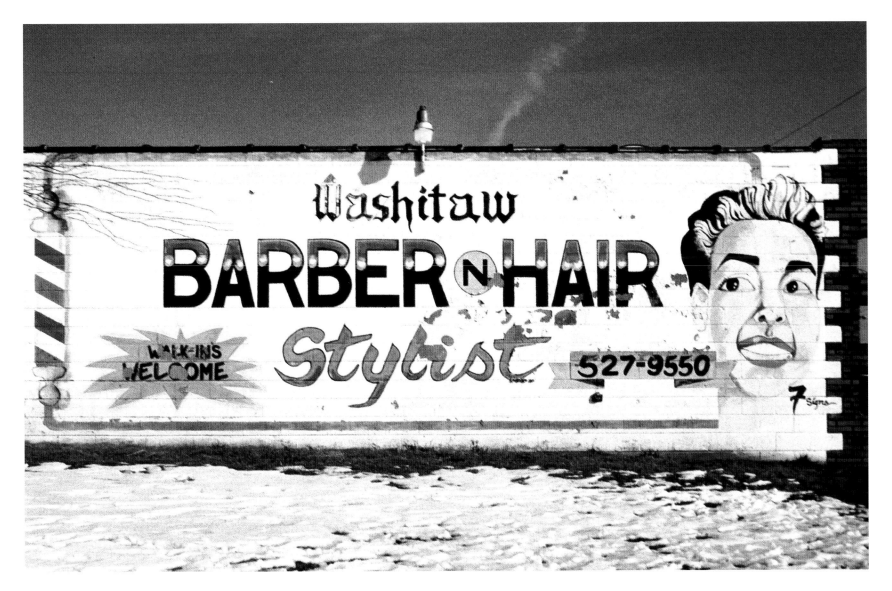

Washitaw Barber N Hair Stylist, 11391 E. McNichols

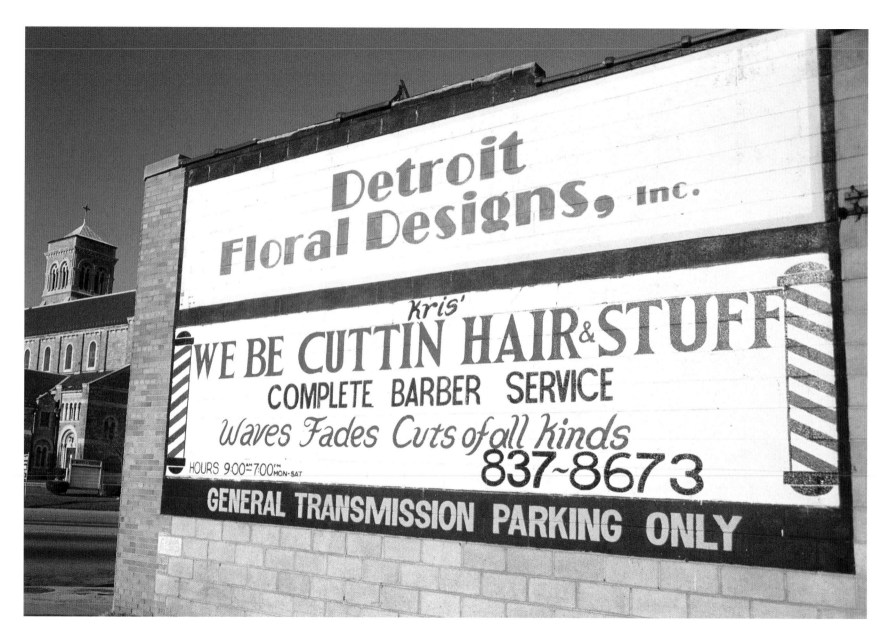

We Be Cuttin Hair and Stuff, Grand River near Oakman

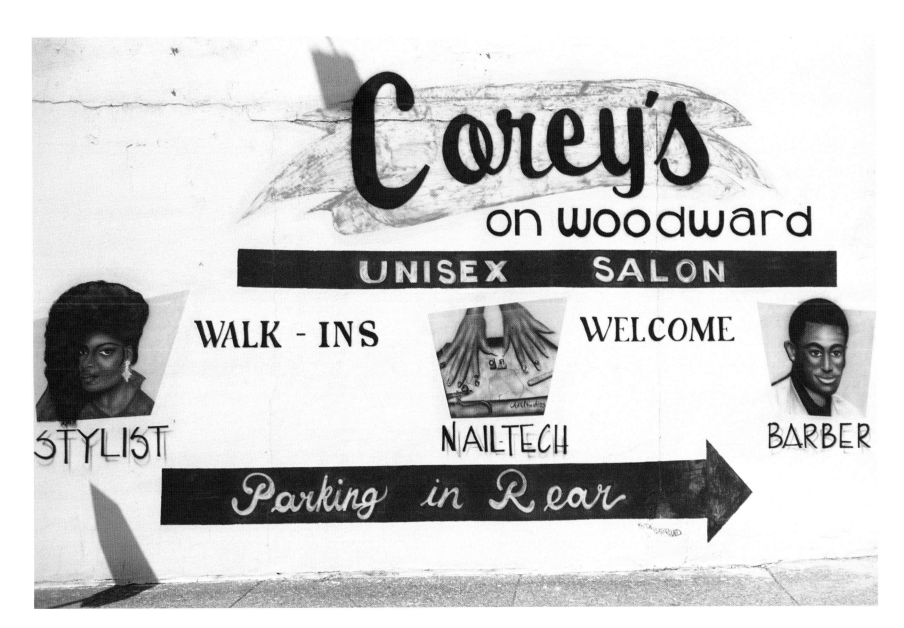

Corey's, 13800 Woodward, Highland Park

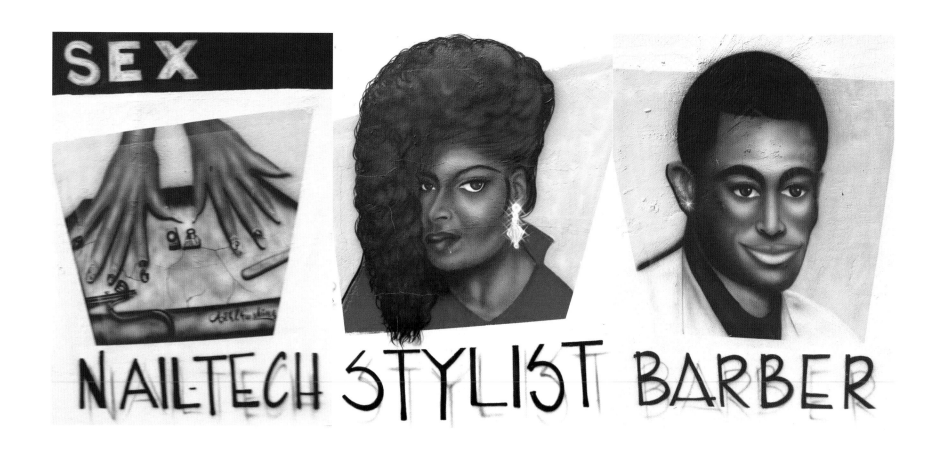

Corey's, 13800 Woodward, Highland Park

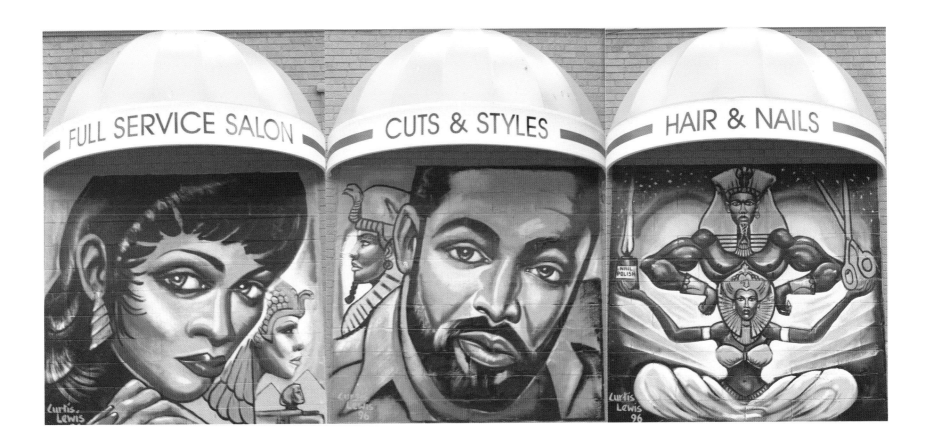

Curtis Full Service Salon, 7041 W. 8 Mile

Afterword

Jerry Herron

Looking at David Clements's photos makes me want to start lining up support for what they're *not*. I have no mandate to do this, nor do the photos need extra help. They do just fine on their own, being what they obviously *are*: the kind of photos you might take to help you remember something interesting you saw on a trip, even if it was one of those Thoreau-like trips you take in your own hometown. "Most men," Thoreau said in *Walden*, "even in this comparatively free country, through mere ignorance and mistake, are so occupied with the factitious cares and superfluously coarse labors of life that its finer fruits cannot be plucked by them." It's that impractical trip away from daily busyness that Clements's photos are meant to inspire—the kind of trip that reminds people of all the things they're ignorant of in a place they think they already know about because they've been so busy living in it, which is how a lot of Americans encounter their hometowns, particularly if those towns happen to be cities that have been largely left behind, cities like Detroit, where, for those us of who still live and work there, the idea that people take all this blankness for granted is a little disturbing. It's difficult to figure out what to make of so much emptiness in a city where over half the popu-

lation just got up and walked away. Detroit's not unique in this way, of course. It's just like every other American metropolis, only more so.

This is precisely where David Clements comes in, and where the real genius of his project lies. Lots of people have taken pictures of cities; cities have played a starring role since the invention of photography and, later, movies. Lately that role has tended toward nostalgia for past glories and cautionary advice about present calamities. A regular cottage industry has sprung up, in fact, producing *Matrix*-like images of empty American cities—as if most of us need to be reminded that cities are not where the majority of Americans live—with the result that a whole lot of wasting has gone on of things and lives that we've abandoned. But that's not news; and it's certainly not anything that the image-makers haven't helped us get used to. And this is what David Clements is—admirably and adamantly—*not* doing. His pictures are not just another re-hash of urban abandonment and devastation, of the "ruin" we've made of our cities. His pictures aren't like this because they aren't really pictures of the city at all. Not really. What

Clements has photographed is signs: messages about the city that are meant to be read.

It's no accident, of course, that he found these signs where he did. Conditions in Detroit, where over 2 million people used to live and just over 900,000 presently call home, have made certain kinds of message-writing necessary. Because of that great outmigration, there's a lot of empty space available for painting. More than that, there's a great need for signing, for explaining things. Again taking Detroit as an example, there's the fact that almost 5 million Americans live near the city (in the greater agglomeration the Census Bureau refers to as "Detroit") but that most of those people whose lifestyles are made possible by Detroit are intent upon not living in it, or even visiting it. It's a distinctly perverse American attitude toward the city and the kinds of history that cities embody, which invites the signing that goes on—back in town, unofficially for the most part—because people need to make sense of the puzzle they inhabit.

And that's just what Clements's photos represent: the vernacular signing that people need to tell each other what's happening with commerce, entertainment, politics, or maybe just to preserve an image of a face that will have meaning only to a few. These are signs born of local necessity and exuberance; they are handmade on-site, not the result of an anonymous corporate installation. Because there's so much to make up for, to cover, in this shamefully uncovered city, the signs can undertake an expansiveness of dimension and color that is truly profligate and admirable.

What Clements is not doing here is making art or politics or irony out of somebody else's necessity or naïveté. This would be easy enough, but he's not turning this or any of his other texts to trade. He's not making fun. He's not trying to be a "great" photographer either, in the way that photographers aspire to, after the examples of Dorothea Lange, say, or Walker Evans, or later, in the deconstructive mode of Diane Arbus or Garry Winogrand. Maybe it's because there are almost never any people in Clements's photos that he avoids getting into personal issues of the gaze, or whose gaze is being sponsored. It's the signs he's interested in rather than the people who made them.

And this separates his work from the connoisseurship that attends so-called outsider art of the sort a less interesting spectator than Clements might want to turn his subjects into. He's not trying to be anywhere except inside the world these signs come from, which accounts for a certain lush repetitiveness of technique. He seems to have photographed everything on the same day at the same time with the same light, enriching each image with the same depth of color. He fills the frame up to the edge with his signs, just as the signs themselves fill up the available spaces of walls and building fronts. There's no getting outside the frame in this visual world. This is a technique that strives for and achieves the opposite of technique in the sense that all the images share with the signs an apparent unselfconsciousness, the same unselfconsciousness of a tourist's photo snapped to record a memory rather than to make something of it that's about more than the information contained inside the frame.

Of course, Clements's images are *not* unselfconscious; they only seem that way, and this is the triumph of his technique as much as a measure of his awareness that he's planted a shrewd running joke in all his texts. And the joke is on us—most of us, at any rate. No matter how superior the viewer may feel to the art and the messages, here we end up wanting something that Clements and his photos withhold knowingly, because they can. We can't help wanting to know more: Where are the signs exactly? What is the neighborhood like? Who painted the images? Could you pull the camera back so I can see who's here? Who wrote the text? Are these places still there? Clements might say it doesn't matter, that these are irrelevant questions, that he's not interested, or that he doesn't have time to find such stuff out. It would be wrong, however, to attribute his withholding to naïveté or laziness. Instead, I think he's turning the tables quite wonderfully on the viewers. It's not the sign painters and vernacular muralists who are "outsiders"; it's us, the viewers.

But I don't want to suggest that there's anything mean-spirited or snide about what Clements is doing. Just the opposite. His procedure is all about respect and ownership, an advocacy that is no less admirable than it is necessary, which is to say he's playing a well-intentioned joke, with implications for photographs and cities alike. The joke is about the kind of phony "rights" that outsiders sometimes feel they're entitled to because of what they think they know or where they're from, which gets back to Thoreau and his dread of people who are always working their knowledge without ever confronting the ignorance upon which their sense of superiority is based. It would be possible, certainly, to make something else out of

Clements's signs: to place them in a context other than their own, to turn them into statements about visual culture, or to appropriate them academically, as texts requiring professorial interpretation, or art-historically, as objects of attribution and conservatorship. But those are wrong choices, according to Clements, which is his reason for withholding the information necessary to proceed along those lines, just as I believe he would find it a wrong choice to talk about the city—whether Detroit or any other city—as if it weren't first of all about the needs of the people who live there, as opposed to the things people who don't live there imagine they know about the city.

That's why his choice of signs is so right, and so smart, and *not* naive. The things Clements has taken pictures of all had a purpose of their own prior to their being photographed, which in this case raises more questions than it settles, as I've suggested. And it's those questions that bear thinking about once the touristic pleasure of looking at these photos has run its course. That's the point another master of faux naive commentary pointed out, famously, in the "Notice" that opens *The Adventures of Huckleberry Finn*: "Persons attempting to find a motive in this narrative will be prosecuted" . . . "persons attempting to find a moral in it will be banished; persons attempting to find a plot in it will be shot." Not that readers haven't done all those things, and not that Mark Twain didn't fully expect they would and even want them to. His point, and I think it might well be Clements's point too, is that when people start exercising their knowledge on a thing that somebody else has made, they at least ought to be clear about whose needs are being served.

Acknowledgments

The author wishes to thank Jayne Rayburn, creative editor; Anthony Bitonti, my constant partner and excellent photographer for all the days spent on the streets; my wife and artist Karin Klue; Dennis Nawrocki of the College of Creative Studies; Chris McNutt; John Hammond; Photo Fast of Birmingham, MI; Daniel Herschberger; and the countless people who have helped with this project. Plus the artists and small business owners who have taken the creative time to communicate commercial messages.

TALKING SHOPS

REGIONAL STUDIES · ART · URBAN STUDIES

"David Clements has taken it upon himself to preserve as many examples on film as one talented photographer can, and to press them between the covers of this book. . . . Wisely, he's chosen to limit his perspective to metropolitan Detroit, a community he knows intimately. But even in that he has accepted a challenge, for the Motor City is among America's richest when it comes to folk advertising art. . . . *Talking Shops* belongs on the coffee table in every living room where the conversation is in danger of losing momentum, and a shelf in every library devoted to photography and the development of the American ideal."

—Loren D. Estleman, author of *Writing the Popular Novel*

"While others might look around the central city and see dirt, decay, and desertion, Clements has eyes for 'outsider' art laced with hot color, brash humor, and high energy on the walls of the city's most modest stores and bars."

—Joy Hakanson Colby, *Detroit News*

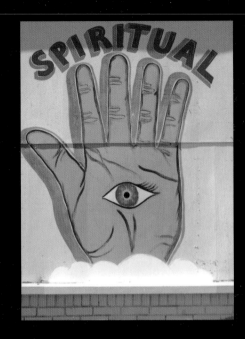

David Clements is a professional producer and director of radio, television, and photography. His work also appears in *Art in Detroit Public Places* (Wayne State University Press, 1999).

Bill Harris is a poet, playwright, and professor of English at Wayne State University and is the author of several publications including *Riffs and Coda* (Broadside Press, 1998).

Jerry Herron is professor of English and American Studies and director of the Honors Program at Wayne State University. He is the author of *AfterCulture: Detroit and the Humiliation of History* (Wayne State University Press, 1993) and is currently finishing a new book on Detroit.

A *Great Lakes Books* publication

Cover photograph: Eastside Check Cashing, 12240 E. McNichols

Cover design by Mary Claire Krzewinski

Wayne State University Press
Detroit, Michigan 48201-1309

ISBN 0-8143-3090-8

9 780814 330906